CHICAGO
BOXING

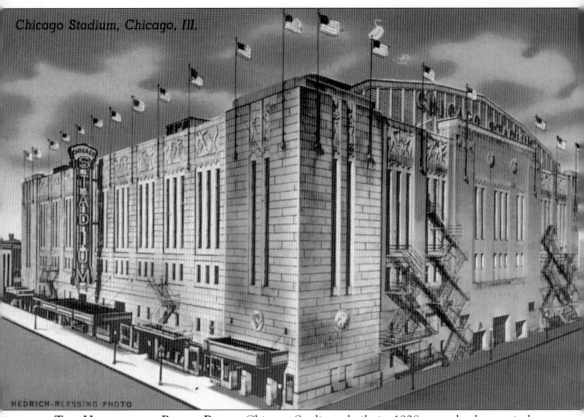

HEDRICH-BLESSING PHOTO

THE HOUSE THAT PADDY BUILT. Chicago Stadium, built in 1928, was the largest indoor boxing arena in the world. Designed to seat 26,000 fans, it was built in the heart of the old Irish "Valley" neighborhood by one of that area's former residents, Paddy Harmon. A promoter who loved boxing, Harmon needed several years to raise the $6 million required to finish the project; but he did it, and on March 28, 1929, the stadium opened with light heavyweight champ Tommy Loughran against middleweight king Mikey Walker in a 10-round bout for Tommy's 175-pound title. The two popular Irishmen drew almost 15, 000 fans and a gross gate of $186,367. Loughran won a ten-round decision. Soon after, Harmon was killed in an auto accident and Jim Mullin took over as promoter, with former manager Nate Lewis as matchmaker. The two were enormously successful. Most of the country's top contenders and champions came to perform in this great arena. Large gates continued to be drawn at Chicago Stadium, even during the darkest days of the Great Depression.

CHICAGO
BOXING

J.J. Johnston and Sean Curtin

ARCADIA

Published by Arcadia Publishing
Charleston SC, Chicago IL, Portsmouth NH, San Francisco CA

Printed in Great Britain

Library of Congress Catalog Card Number: 2004112279

For all general information contact Arcadia Publishing at:
Telephone 843-853-2070
Fax 843-853-0044
E-mail sales@arcadiapublishing.com
For customer service and orders:
Toll-Free 1-888-313-2665

Visit us on the internet at http://www.arcadiapublishing.com

CHICAGO PUGILIST GREATS. In this 1955 photo, from left to right, are: (front row) Johnny Coulon, Eddie Lander, Davey Day, and Harold Brown; (back row) Ted Ross, Dave Schimmel, Stanley Berg, Al Lander, George White, Red Shea, and Danny Spunt.

CONTENTS

DEDICATIONS

This book is dedicated to boxing historians Dr. Nick Beck, of Los Angeles, California, the late Bob Soderman of Chicago, Illinois, and the late Bob Shepard of New York City.

– J.J. Johnston

To Chuck Bodak, my boxing mentor, and to my Army coach Sgt. Earl K. Hussey.

– Sean Curtin

Thanks to Dan Cuoco and the IBRO members for their help and contributions.

To all the memorable boxers (and their families) that are not in this book, the authors regret that due to a lack of photos not all top Chicago fighters could be included. Thank you for all the thrills you have provided Chicago fans over the years.

FOREWORD

Lord Buckley's apothegm on the life of Christ was this: "When the Naz laid it down, it stayed down." So have we always said about J.J. Johnston. The we, of which I am proud to be a part, is that group of writers, show folk and general neer-do-wells who came together in the Chicago of the late '60s. We knew J.J., initially, as an actor and raconteur; it took some longer acquaintance to recognize in him the best of historians.

In his allied areas of expertise—American Crime and American Boxing—his interlocutors have yet to find him at a loss.

Ask who was the Bartender at Little Bohemia, or who was Terry McGovern's favorite cut man, and you get not only an immediate answer, but a correction, and midrash. "The books say X, but it was really Y, and let me tell you a story about that...." This guy is the real McCoy, and let me tell you a story about that. I was asked to write a film about John Dillinger, so I called up J.J. "I'm going to a meeting," I said, "Would you come along and front for me?"

He of course said of course, and off we went to the Bel Air Hotel, there to meet several adolescent moguls. J.J. showed up with some WANTED posters, which he put on the table, and a rumpled paper bag, which he put at his feet. The posters were original, desiring the whereabouts of Alvin Karpis, Pretty Boy Floyd, Dillinger, Baby Face Nelson, et cetera.

J.J. held the breakfast meeting entranced until two in the afternoon, when the young things decided to migrate back to work.

One of them, on rising, said, "You know, Dillnger's looks changed drastically in the last months of his life. After that plastic surgery. In fact, they took a death mask of him, showing the remarkable discrepancy. They made two. One is at the F.B.I. building, in Washington, and I don't know where the other one is."

"It's right here," J.J. said, and produced it from the paper bag at his feet.

This boxing book similarly, and in the highest praise of our Chicago coterie, is The Real Deal.

I read it and hear his inimitable voice laying it down. I'm sure you will, too; I wish you could hear him in person.

David Mamet
June 8, 2004

AMATEUR EXCITEMENT. Taken a few year after big time bouts had returned to Chicago, this terrific 1929 ringside photo captures the thrill of amateur boxing kept alive during the "boxing in limbo" era in the city. Depsite the fixed Gans-McGovern bout in 1900 sending marquee

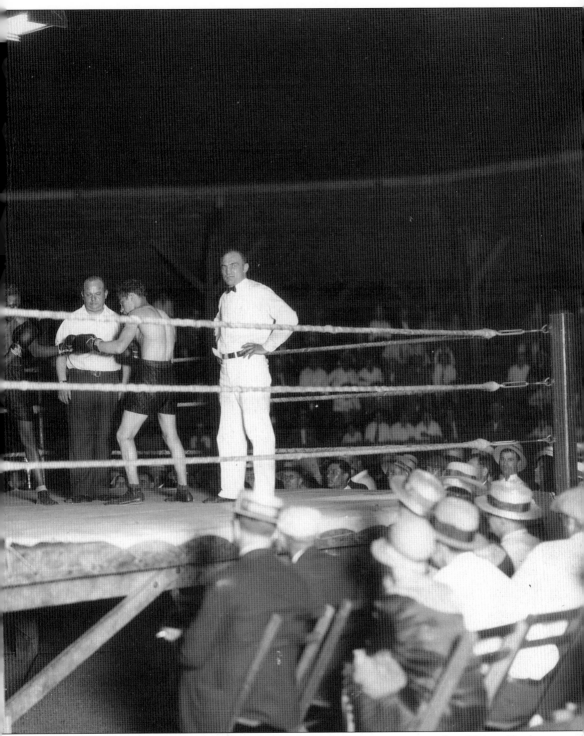

fighters and championship matches out of town for a whole quarter-century (see Chapter Two), Chicagoans continued to embrace the sport as much as anyone in the country. Note the packed house and the excited young fan to the left.

THE CHICAGO COLISEUM. The Coliseum was constructed in 1889 of bricks and stones from the Notorius Libby prison in Richmond, Virginia where Union prisoners were kept by their Confederate captors during the Civil War. The Coliseum was erected between 14th and 16th Street on Wabash Avenue as the Libby Prison Museum. It was rebuilt once more as the Chicago Coliseum in 1900 and became the scene of the first national auto show that year. In 1904, it was used for the Republican Party which nominated Theodore Roosevelt, and it became the number one convention site for many years. It also housed other events such as Circuses, Wild West shows, Travel Expositions, etc. Professional sports made their debut at the Coliseum with wrestling and the newly formed Chicago Blackhawks Hockey team. Boxing became legal and in 1926, Mickey Walker won the middleweight title from Tiger Flowers in the first of several championship fights held there. It was promoted by an African American named Fred Irvin.

ONE

19th Century
Pugilists, Promoters and Politicos

Boxing in Chicago really began after the Civil War. The town was booming with industry and the population was soaring, and fighters came from other parts of the country to compete, even though the sport was illegal in Chicago as well as the entire state of Illinois.

In the beginning, matches were held in the back rooms of saloons, in barns, and on the beaches of Lake Michigan. These were both bare-knuckle and glove contests. Some were fights to the finish while others were a specified number of rounds. These were brutal affairs with prize money divided unequally; the larger take went to the winners and smaller amounts to the losers. Some were "winner take all" contests, and the wagering was tremendous.

The foremost Promoter was a tough and resourceful Irishman named Dominick O'Malley. He held fights on the sneak, and if the heat was on in the city, he would stage matches across the state line in Roby, Indiana, or on a nearby beach in Michigan.

In Chicago, O'Malley's principle supporter was the gambling boss Mike McDonald, a boxing fan and sometime referee. When Chicago held its first World's Fair in 1893, Mayor Carter Harrison, Sr. permitted fights to be held openly with paid admissions at spacious Battery D Amory Arena. McDonald selected the promoter, a wily gambler and friend named Parson Davies. Davies was not a clergy man, he just dressed like one.

Boxing became an "on-again off-again" matter under Mayor Carter Harrison, Sr. and his son and successor Carter Harrison, Jr., both of whom were assassinated while in office. Still, arenas sprang up around the city. Among them were Apollo Hall at 12th and Blue Island; McGurns, at Davison and Wells; and the American, at 31st and Indiana. And many great champions like Jack McAllife, George Dixon, Kid Lavigne, the original Joe Walcott, Tommy Ryan, and Kid McCoy came to fight in Chicago. (McCoy was knocked out in one round by a second-rater named Jack McCormick in one of the era's biggest upsets.)

But because boxing matches in Chicago were limited to six rounds, big money fights of 20 and 25 rounds went to the West Coast. When Lou Houseman became the top Chicago promoter, after Parson Davies headed west, several bills to legalize boxing and permit longer fights were introduced in the Illinois Legislature; but they were always defeated. Not until the 1893 Columbian Exposition would things really look up for Chicago boxing.

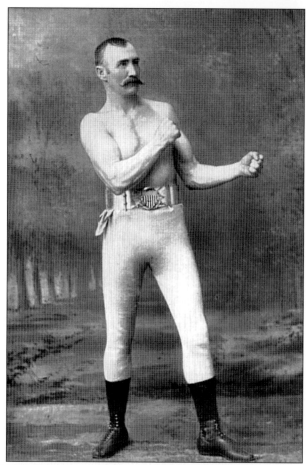

PROFESSOR MIKE DONOVAN. Mike Donovan was born in Chicago in 1842. Still a teenager when the Civil War started in 1861, he joined the 71st Illinois Volunteers, saw action with this regiment in all their major battles, and was decorated for bravery. Mike had been taught to box before the war by his brother, Jerry, who was a professional. He continued to perfect his skills whenever he could find an opponent among his fellow soldiers. Size was not important to Donovan, who never weighed more than 160 pounds. He had both speed and a powerful punch, and the bigger soldiers proved easy prey. Mike was also a very clever boxer with a strong defense, difficult to hit cleanly.

After the war, Donovan began boxing professionally and soon became the middleweight champion of America. He could box 60 or 90 rounds bare knuckle, or go 10 rounds wearing gloves; either way, he beat all the contenders. He even fought a pair of three-round exhibitions to a draw with future heavyweight legend John L. Sullivan, who outweighed him by 50 pounds. In a career that lasted until 1891, Donovan won 24 of his 33 matches, fought to seven draws, and lost only two fights—both on fouls.

After retiring from the ring, he became a boxing instructor at the New York Athletic Club, a post he held for 38 years. Future President Theodore Roosevelt was one of his students, and Donovan was later a frequent visitor to the White House, where he would spar with the Chief Executive.

Donovan died in 1918. His son, Arthur, who boxed professionally and also served as his father's assistant, spent 50 years as a coach at the NYAC. Arthur Donovan also became the most famous referee in New York City. His son, Artie Donovan, was a great football player with the champion Baltimore Colts and later became an author and television personality.

HARRY GILMORE—MAKER OF CHAMPIONS. Gilmore was Chicago boxing's greatest teacher. His pupils included champions and top contenders. *Right:* Gilmore was a good fighter in his own right and at one time in the 1870s claimed the featherweight title. After running out of opponents in that division, he challenged undefeated Jack McAuliffe for the lightweight crown. On January 13, 1887, after a furious fight, Harry was stopped in the 28th round. Thereafter, he devoted himself to his protégés and his boxing academy at McGurn's Handball Court. (Photo from Harry Shaffer.)
Below: Gilmore (front row, center) is seen with his top pupils, clockwise from lower left, Jimmy Barry, Frank Gerrard, Tommy White, George Kirwin, Eddie Santry, and Harry Forbes.

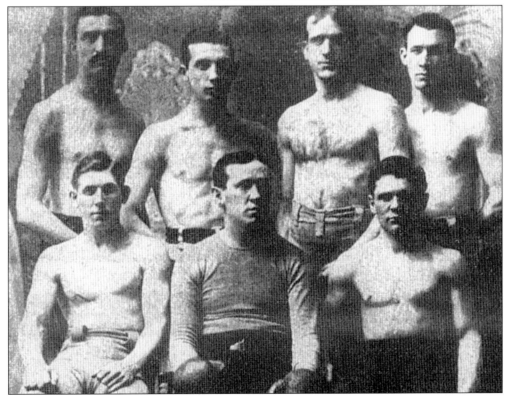

13

JIMMY BARRY—UNDEFEATED CHAMPION. Jimmy, called the "Little Tiger," was the first of Chicago's five bantamweight champions and perhaps the best. He was born and raised on the Chicago's Southside. A protégé of Harry Gilmore, the hard-hitting Barry turned pro in 1891 and quickly became a Chicago fan favorite. He hit with surprising power for a boy who only weighed a little over a 100 pounds. In a just few years, he had taken on and knocked out most of the top fighters in his weight class , and many who were heavier. Finally, on September 15, 1894, he challenged the highly regarded Casper Leon in Lamont, Illinois, and knocked him out in 28 rounds to claim the world 118-pound title.

In 1897, after continuing his winning ways for three years, Jimmy Barry sailed off to London, England, to meet the British champion, Walter Croot, in a December 6 match to determine the undisputed bantamweight champion of the world. Croot was knocked out in the 20th round. He suffered a brain injury and died. The crestfallen Barry was exonerated by the coroner's jury, but was never the same in the ring again. Afraid of causing serious injury, he held back on his punches and never scored another knockout. (He had KO'd an amazing 38 out of 60 bouts.) He retired, undefeated, in 1899. Barry died in April of 1943, in Chicago, at 73 years of age.

ST. PADDY'S DAY BRAWL. Jimmy Barry (right) squared off against fellow Irishman, Johmmy Conners, on Saint Patrick's Day, 1898, at Chicago's Irish Hall. Barry won the six-round decision.

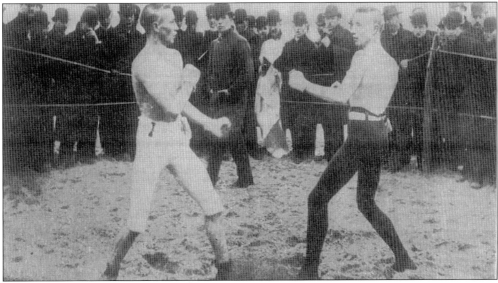

TOMMY WHITE. White (left) squares off against Billy Brennan on Chicago's lake shore. Looking on inside the ring is Malachi Hogan—referee, saloon keeper, and popular sports writer. Tommy was the first of Harry Gilmore's pupils to establish a national reputation. At the tender age of 16, he could hold his own with the best featherweights, and he claimed the title. Wearing 2-ounce gloves, White took part in one of the longest bouts in history—a match to the finish against Danny Daly that went 91 rounds, lasted six hours and ended in a draw. A very tough little Irishman, he also fought to a draw with the great George Dixon, but was stopped in a match with the murderous champion, Terry McGovern. Tommy then retired and went to work for the post office. He also became a trainer and worked for the Catholic Youth Organiztion (CYO).

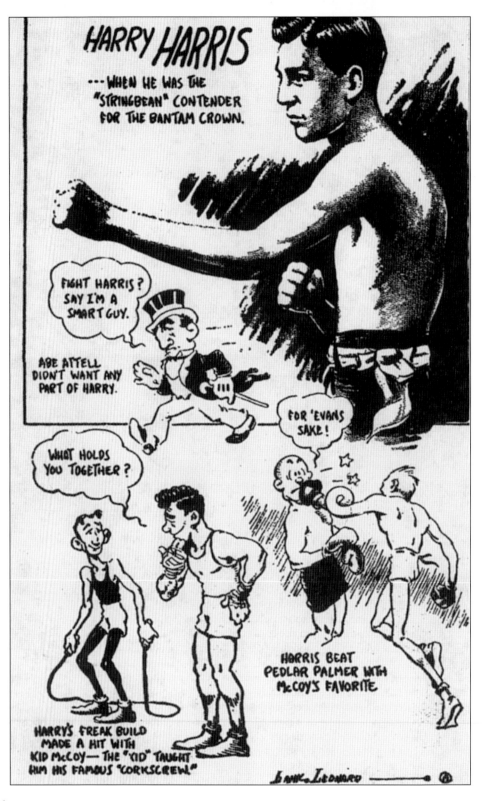

16

HARRY FORBES. Harry, a tough little Irishman born in Rockford, Illinois, in 1879, moved to Chicago and launched a busy boxing career in 1897. He was another protégé of Harry Gilmore and had an amazing 130 bouts against the best little men of his day, often in his opponents' home towns. On April 2, 1901, in his fourth meeting with Casper Leon, Forbes won a 20-round decision in Memphis and with it took the vacant bantamweight title. He beat future featherweight champ Abe Attell the same year, winning on points after 15 rounds, and defended his title four times before losing it to Frankie Neil (who he had previously defeated) by a second-round knockout in 1903. (Harry's brother Clarence, another good little fighter, had been knocked out by Frankie Neil earlier that year to earn Neil the rematch with Harry.) Forbes fought until 1913, and afterward had a good job for years at City Hall. He also became a boxing promoter. Harry Forbes died at the age of 67 in Chicago in December, 1947.

Opposite: **HAIRPIN HARRY HARRIS—CHICAGO'S FIRST JEWISH CHAMPION.** Harry Harris and his twin brother, Sammy, were born in 1880 and raised on Chicago's Southside, where they took up boxing at an early age. Sammy was good and was making the grade, but died young after a brief professional career. Harry, who turned pro at the age of 15, came under the wing of the famous Kid McCoy, who taught him the tricks of the trade, including the celebrated "Corkskrew Punch." As bantamweight who stood 5-feet-8 and had an unusually long reach, Harris was soon beating all the local boys and was finally matched with undefeated world champion Jimmy Barry. Harris appeared to be the clear winner, but the match was declared a draw and Barry announced his retirement as the unbeaten titleholder. Not discouraged, Harry traveled to London, England, where he beat the Empire champ, Pedlar Palmer, and gained recognition as the 118-pound king. He retired as champ in 1907, took a position managing theatres for A.L. Erlanger, and married famous actress Desiree Lazard. Harris pursued a seat on the New York Stock Exchange, which he joined and in which he was very successful, retiring a wealthy man in 1930. As a member of the New York Athletic Club, he gave a young Gene Tunney some tips on the manly art. Harry Harris died June 5, 1959, at the age of 78.

17

EDDIE SANTRY—BOXING TO POLITICS. Eddie Santry was another of Harry Gilmore's Boxing pupils. He was a classy featherweight who could outpoint anyone near his weight on a good day. But he was not particularly rugged and was knocked out in several major bouts. In 1899, Santry almost won the world title when he fought to a 20-round draw with the great George Dixon. In his next fight, he knocked out Ben Jordon of England to capture the British title. In 1900, in Chicago, he was KO'd by "Terrible" Terry McGovern in another try for the featherweight crown. He fought for several more years, winning most of his contests but getting knocked out in the big ones. He retired from the ring in 1911 to enter politics and was elected to the Illinois State Legislature. Santry was very popular and was re-elected several times from his district. He was still in office when he died in 1919, just 43 years old. (Photo courtesy of Harry Shaffer.)

DEATH IN THE RING. Dutch Neal (left) was killed while sparring with Harry Peppers in a Chicago gym, in 1900. It happened a short time before the infamous Gans-McGovern "fight" in November in Chicago. The man on the right is manager James Courtney. (Photo courtesy of Bob Carson.)

TWO

The Big Fix
Chicago Boxing in Limbo

Chicago greeted the new century as the fastest growing city in America. And boxing, already enormously popular in most cities in the country, was crying for acceptance in the city. The "exhibition only" sport had moved out of the notorious roughneck clubs and into large arenas, and bills to legalize it were introduced in the state capitol in Springfield and before the Chicago City Council. Still, these bills went nowhere, and only the less grand six-round bouts were allowed.

For the young Chicago-area fighters on their way up, six-round bouts were okay. But after they'd had a couple of years of experience, it was time to move on to longer fights, bigger purses, and higher caliber opponents.

The big money at the time was on the West Coast, in San Francisco and Los Angeles, where matches up to 45 rounds were permitted. These fights drew large gates and for the most part were held outdoors. New York also staged important fights, although they were limited to 10-round "no decision" contests; and titles changed hands only when a champion was knocked out.

After 1908, even six-rounds fights were rare in Chicago, and top boxers such as Battling Nelson, Packey McFarland, Jack Britton, and Johnny Coulon had moved on to greener pastures. At the same time, most of the good trainers and managers also left Chicago. Except for Milwaukee, boxing was virtually dead throughout the Midwest.

Between 1908 and 1915, a few boxing shows, mostly billed as charity events or exhibitions, were promoted in Chicago. One of the promoters was Sammy Wolf, whose boxing club was called the Portable A.C. because he moved the location each time he put on a show. But that was the extent of Chicago boxing during this era.

The illegality of boxing in Chicago, and the subsequent absence of any notable ring events between 1900 and 1925, can be linked to a single bout—the "Big Fix"—which occurred at the very onset of the new century.

At the time, the two best boxers in America—unquestionably—were Joe Gans and featherweight champion "Terrible Terry" McGovern. The African-American Gans, already known as the "Old Master," was considered by most fans as the "uncrowned" lightweight

19

champion. Black fighters of the era often had to take the short end of the gate receipts if they wanted to face top white opponents; and frequently they had to "carry" a good local boy or go into the tank and lose by a knockout in order to get a payday. But Gans and McGovern were both so highly regarded that when a match between them was scheduled for December 13, 1900, Chicago's Tattersalls Arena was packed to the rafters with more than 17,000 fans. By the regulations then in effect, the bout was limited to six rounds; and because Gans was bigger and heavier, he was required to weigh-in at ringside at no more than 133 pounds.

McGovern had won his title from the great George Dixon by a knockout the previous January and had KO'd Chicago favorite Eddie Santry at Tattersalls in February. A year earlier he had flattened Harry Forbes to win the bantamweight title and also knocked out lightweight champ Frank Erne, who owned a victory over Gans. Even though he would come in ten pounds lighter than Gans, Terry was given a good chance by fans and the gamblers.

The betting opened at 1 to 2 on Gans, but by the day of the bout McGovern was the favorite. Surprisingly, much of the money bet on McGovern was coming from the "Black Belt," where fans apparently suspected that their idol Gans would be knocked out. Referee George Siler, beneath hot ring lights required to accommodate the motion picture cameras, gave the fighters instructions, asked them to shake hands, and signaled that the match was on. But it hardly could be called a fight. Gans came out of his corner looking scared and was floored by a roundhouse right. In two rounds he was knocked down seven times and Siler counted him out.

The outraged mayor and the city council immediately issued an order that no more professional boxing would be allowed in Chicago, except in "members only" clubs, such as the Chicago Athletic Association. Gans, a known gambler, went on to live down the Chicago "fiasco" and in 1902 he won the world lightweight championship. But before his death from tuberculosis in 1910 he admitted that he, his manager, and an unnamed crony had fixed the McGovern fight and that he had taken a "dive." McGovern, who later developed mental problems and died in an insane asylum in 1918, had had no part in the "fix."

Perhaps the real victim of the Gans-McGovern match was boxing itself. It would not become legal in Chicago until 1925.

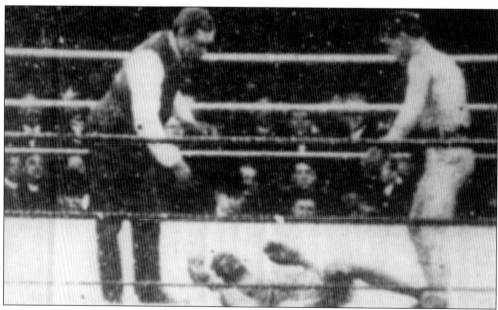

DOWN FOR THE COUNT. That's Gans on the canvas, with McGovern (right) towering above while referee George Siler counts him out. But, as the sequence on the following page shows, there was not much of a knockout punch invloved in this KO.

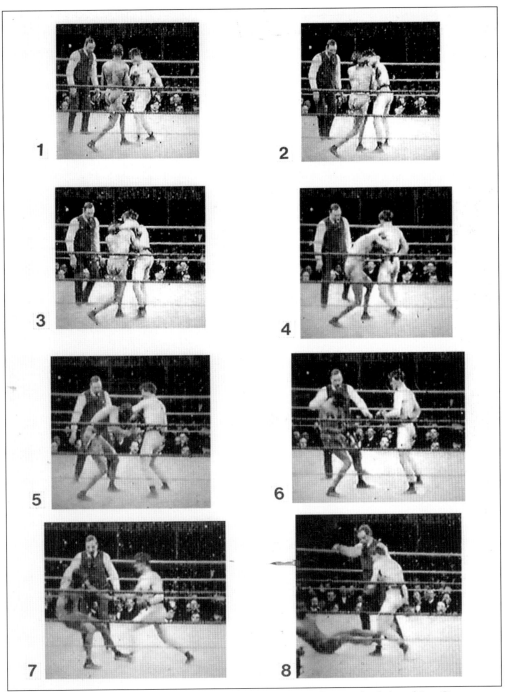

THE BIG FIX. Featherweight champion "Terrible Terry" McGovern (right) and Joe Gans square off in what would become the most infamous bout in Chicago's early boxing history. In December of 1900, Joe Gans took a dive, hitting the canvas several times in two rounds and then being counted out by the referee. It was an act that would set Chicago boxing back 25 years. These stills from a rare vintage filming of the bout show Gans being "knocked down" by an apparent left from McGovern. (Photo courtesy of Steve Lott of Big Fights, Inc., and Steve Compton.)

GEORGE GARDNER—LIGHT-HEAVYWEIGHT CHAMPION. George and his brother Jimmy Gardner, also a champion, were born in Ireland but raised in Boston. George did most of his fighting in New England and California before making his first appearance in Chicago in 1902. He liked the city so much he settled there. Gardner faced some of the best of his era, including Jack Johnson, George Byers, Joe Walcott, and Frank Craig. He won the 175-pound title in 1903 by knocking out Chicagoan Jack Root, but lost it, in his first defense, to former heavyweight champion, old Bob Fitzsimmons. After losing the tile, Gardner had an up-and-down career. He retired from the ring in 1908 and opened a saloon on the Northside which he operated for many years. He also promoted boxing shows. He was 77 when he died in 1954.

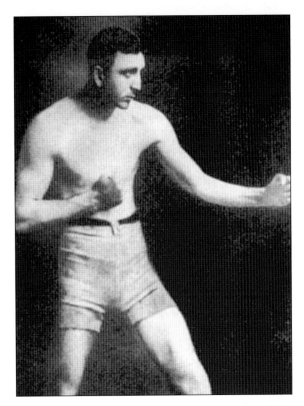

Opposite: **JACK ROOT—FIRST LIGHT-HEAVYWEIGHT CHAMP.** Root was born Janos Ruthaly on May 26, 1876. His Bohemian parents immigrated to Chicago when Janos was three. He started boxing at the Chicago National Athletic Club and by 1897 had turned professional under the name Jack Root. His manager and promoter was Lou Houseman, sports editor of the *Chicago Inter Ocean.* Houseman also managed the great Tommy Ryan, and Ryan took Root under his wing and taught him a new style of boxing. Root responded by beating a number of top middleweight fighters, among them Billy Stift, Alex Greggains and Frank Craig. In 1900, Root even beat his mentor, Ryan, and another good fighter, Dan Creedon.

Although Root was beating bigger men wherever he fought, he was regarded as too small for the heavyweight division; so Houseman created a new "light heavyweight" division, at 175 pounds. On April 22, 1902, in Detroit, with Bat Masterson as referee, Root out pointed the famous Kid McCoy in 10 rounds to claim the new title. He lost the championship in his first defense, on July 4, 1903, to George Gardner in Fort Erie, Ontario, Canada, by knockout in 12 rounds. He had split two previous matches with Gardner and immediately began campaigning for another shot at the Irishman. Before Jack could get a rematch, however, Gardner lost the title to Bob Fitzsimmons. Only then did Gardner agree to meet Root again, and they fought not one, but two six-round bouts in Chicago, in February and in May of 1904; the first was a draw, but Root won the second on a decision. These two hated each other.

Root then out pointed the rugged "Fireman" Jim Flynn, and with the victory earned a shot at the world heavyweight championship recently vacated by Jim Jeffries. But it was not to be, and Jack was knocked out in 12 rounds by Marvin Hart in Reno, Nevada, on July 3, 1905, with Jeffries serving as referee.

Jack had only one more fight, which he won, and then he too retired. He bought the Chicago Dime Museum for $2,000 in 1907 and made it such a success that he was able to acquire vaudeville and movie theaters. He then moved to Los Angeles, where he invested in real estate and became an authentic millionaire. He died in L.A. on June 10, 1963, at age 87.

BATTLING NELSON—THE DURABLE DANE. Oscar Nielson was born in Copenhagen, Denmark, in 1882, but grew up in the small town of Hegewisch before it became part of Chicago. "Battling Nelson," as he would be known, became a professional boxer in 1896 and compiled a decent early record, although an abnormally slow heartbeat often worked against him in Chicago, where matches were limited to six rounds. His fights frequently ended before he was fully warmed up and the frustrated Nelson found himself out-pointed by clever fighters who could move and stay out of danger over the short duration.

Bat finally headed for California, where 20 round matches were common. In less than a year, he knocked out San Francisco favorites Eddie Hanlon in 19 rounds, Young Corbett in 10, and Jimmy Britt in 18 rounds; and he found himself the biggest draw in the sport.

Nelson then faced the great Joe Gans in September of 1906 in Goldfield, Nevada, for the world lightweight title. He lost on a foul after 42 rounds, but he won the rematch and the championship by knocking out Gans in 17 rounds in San Francisco on July 4, 1908, a feat he repeated, in 21 rounds, in their rubber match the following September in Colma, California.

Nelson had made a small fortune in the ring and parlayed his fame and wealth into a marriage with the well-known artist and writer Fay King. After the third fight with Gans, he twice defended the title before running into tough Ad Wolgast, who took his crown on a technical knockout in 40 rounds at Point Richmond, California, on February 22, 1910. It was remembered as a particularly brutal affair.

Bat fought on for several more years but never got another chance at the title. Eventually he lost all of his money and was divorced by his wife. In later years he worked for the Chicago Post Office, but when his eyes began to fail he was forced to live on a small pension and aid from the Veteran Boxers Association. Because he had donated $1,000 to the city of San Francisco after the 1906 quake and fire, the nearly destitute ex-champ was the recipient of a $2,000 donation from Bay area fans.

Still, his condition continued to deteriorate and Nelson was finally committed to the Chicago State Hospital. When he died at age 71 in 1954, his ex-wife, Fay, now a newspaper columnist, paid his funeral expenses. His old nemesis, Wolgast, died just one year later, in California.

FRANK CRAIG. Known as the "Harlem Coffee Cooler," Craig fought many of the top boxers of the era, including Jack Johnson.

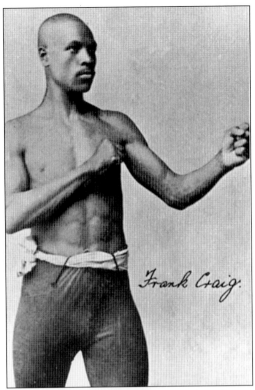

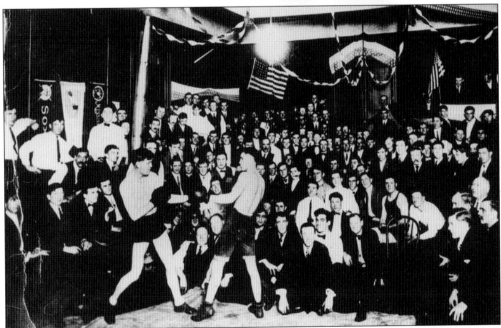

ATHLETIC CLUB BOUT. For a quarter century after the Gans-McGovern bout (1900–1925) the only legal boxing matches to be found in Chicago were at places like the South Deering Pleasure and Athletic Club, pictured here in 1912. Seen here, Jack O'Keefe (left) squares off against Tim O'Neill. (Photo courtesy of Rob Sellers and Dominic A. Pacyga.)

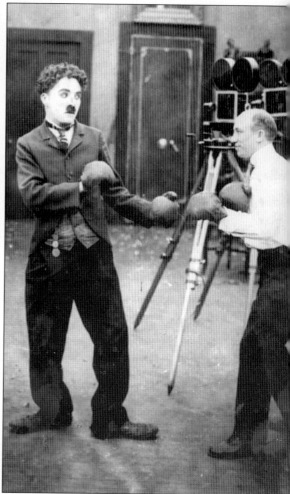

JOHNNY COULON—THE MAN THEY COULD NOT LIFT. Coulon—seen here as a young bantamweight *(left)*, "sparring" years later with film star Charlie Chaplin *(center)*, and in his golden years as a manager posing with his wife Marie and his champ, Eddie Perkins *(right)*—was one of the most amazing boxers in history. He was born and bred, almost from infancy, to box by his father Pop Coulon. The family moved to Chicago from Toronto, Canada, when Johnny was a child. Pop had been a boxer and he put the love of the sport into Johnny and his brother as soon as they could hold up their "dukes."

Johnny, a brilliant boxer and the fastest thing in Chicago amateur boxing, turned pro at 15. He defeated all the local talent and soon the promoters were bringing in fighters from all over the Midwest to oppose him. He had won 26 straight until the notorious vice boss John Torrio imported veteran New York bantamweight Kid Murphy, who won a close decision over Coulon in Milwaukee.

Coulon and Murphy were rematched a year later for the American bantamweight title in Peoria, Illinois, and this time Johnny won and gave Chicago another 118-pound champion. In 1910, Coulon knocked out the English champion, Jem Kendrick, in 19 rounds and received recognition as world champion. In 1912, he accomplished one of the most amazing feats in boxing history by defending his title against the top two contenders—in 20-round fights just fifteen days apart, and in two different cities. The opponents were Frankie Conley, whom he defeated in Vernon, California, on February 3, and Frankie Burns, who he beat on February 18,

in New Orleans.

Johnny lost the title in 1914 at Vernon to the great Kid Williams. It was just the second loss for Coulon in ten years. In 1918–19 Coulon served as an instructor for the American Expeditionary Forces in Europe. He even had a couple of fights in Paris in 1920 (losing by knockout in his final match to European bantamweight champion Charlie Ledoux); and it was there that he learned the secret that would make him famous as "The Man They Cannot Lift." The trick was that he would place his index finger on a person's neck in such a way as to render the man powerless to lift him, even though Johnny by then weighed no more than 110 pounds.

In 1922, Coulon and his new bride, a pretty little Irish lady named Marie Maloney, opened a gymnasium at 1154 E. 63rd Street, where they stayed in business for more than 50 years. Mrs. Coulon kept the cleanest gym in Chicago and also was a smart matchmaker who knew the fight racket from A to Z. Johnny taught hundreds of kids his style of boxing and served as trainer, manager, matchmaker, and promoter. He never drank or smoked and when he was an old man he still could box like a youngster. Coulon realized another life's ambition in December of 1962 when Eddie Perkins, who he managed, won the junior welterweight title by beating Duilio Loi in Milan, Italy. Coulon and Eddie made several successful defenses throughout the world, and Johnny continued to amaze people with his lifting act. Coulon was 84 when he died on October 29, 1973.

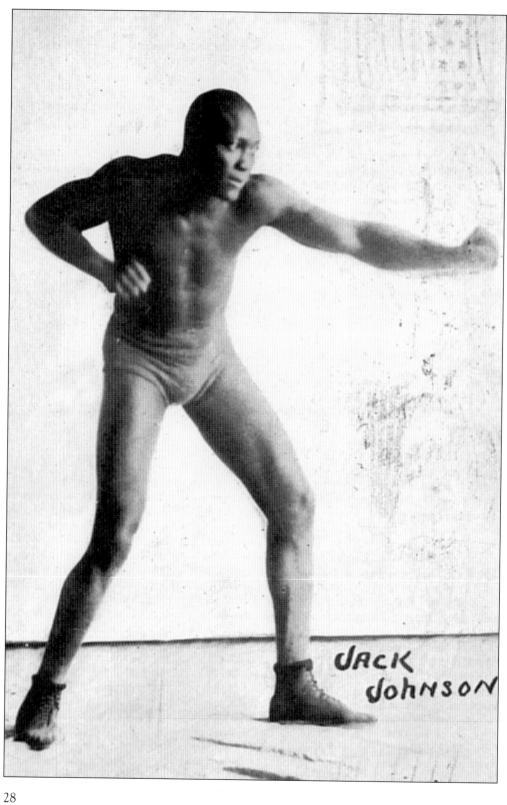

JACK
JOHNSON

Ruby Bob Fitzsimmons— Middleweight, Light-Heavy, and Heavyweight Champion.

This remarkable Aussie, who rarely weighed more than 160 pounds, won three world titles and fought for more than 30 years. He was appearing at a Chicago vaudeville house on October 22, 1917, when he died of pneumonia. He is buried in Graceland Cemetery, not far from the grave of an old opponent, Jack Johnson. Although Fitzsimmons had made a fortune in the ring, he was virtually broke when he died.

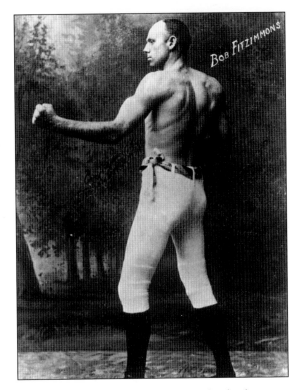

Opposite: **JACK JOHNSON.** The future heavyweight champion came to Chicago for the first time in 1899. He'd had a few fights in and around his hometown of Galveston, Texas, but he wasn't ready for the experienced John "Klondike" Haynes and was knocked out in five rounds. He had a little better luck in his second appearance in the Windy City, in January, 1902, when he boxed a six-round draw with the highly-regarded Frank Childs. Johnson returned a third time, in June, 1904, as the "Negro heavyweight champion," and this time he out pointed Childs in six.

Jack never again fought in Chicago, although he loved the city and decided to settle on the Southside. He moved his mother to the city, purchased a home for her, and opened the Cafe de Champion at 31st and State Streets. In 1912, two years after he had easily defended the world title against former champion Jim Jeffries, Johnson was indicted for violation of the Mann Act, a federal offense. He was charged with taking a woman across a state line for immoral purposes. The law had been enacted to curb organized prostitution, and the boxer was clearly targeted unfairly because of his well-known penchant for the company of white women.

Jack fled to France, continued his career, and did not return to the United States for almost eight years. At age 37, overweight and out of shape, he lost the title to Jess Willard in Havana, Cuba, in 1915. Johnson boxed in Spain and Mexico until 1920, when he agreed to surrender to U. S. officials and serve time in the Leavenworth, Kansas, federal prison. He was released after a year and in 1923 tried to resume his ring career. Time had robbed him of his great skills, however, and he never again was in the big money.

Johnson instead turned to entertainment, appearing with his own jazz band, playing small parts in movies, and "starring" in vaudeville and burlesque. He married for a fourth time, to Irene Pineau, and they lived in Chicago. In 1946 he took a job at Hubert's Museum in New York, where he lectured and did boxing exhibitions. In June he took time out to make an appearance in a Texas circus, and was killed in an automobile accident in Raleigh, N.C., on the trip back to Manhattan. Jack Johnson is buried in Graceland Cemetery, on Chicago's Northside, next to his former wife, Etta Duryea, who had committed suicide years earlier.

29

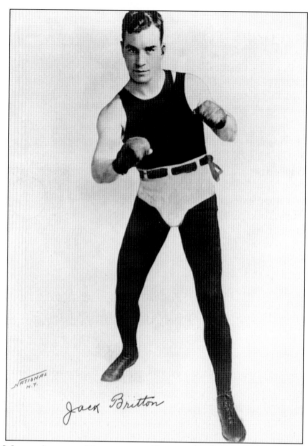

Jack Britton

JACK BRITTON—MOST ACTIVE CHAMPION. Britton had an amazing 342 fights in a 25-year career. He began in Chicago in 1905 and continued until 1930. This clever but light-hitting Irish-American, whose real name was William Breslin, was raised in the Stockyard District; but because his family had moved to Chicago from New Britain, Connecticut, his friends called him "Briton." Jack expressed his resentment at the nickname with his fists, but he finally accepted it, provided it was spelled "Britton." After a brief amateur career, he became a professional boxer.

Because boxing was such a sometime thing in Chicago at that time, Britton soon headed for the East Coast and began making a reputation as a top welterweight. He took on the best fighters from across the country, often in their own home towns, and won the vacant world title on a 12-round decision over Mike Glover in Boston on June 22, 1915.

Jack's bitterest rival was the tough Englishman, Ted "Kid" Lewis (Gershon Mendeloff), whom he faced an astounding 20 times. They exchanged the 147-pound title in several of these contests. Finally, Jack scored a surprising knockout over Lewis in their 18th match and then easily won their last two bouts. His knockout of Lewis was one of only 28 that Britton scored in his career. He was KO'd only once, and that came in his first year as a pro.

Britton, whose accurate left hand and defensive abilities made him one of the most respected boxers in history, lost the welterweight title in 1922 to another Irish-American, the great Mickey Walker.

After retirement, Jack lost almost all of his savings in a Florida real estate scheme. Thereafter, he taught boxing at the Downtown Athletic Club and the Catholic Youth Organization in New York City. His son, Bobby, tried his fists as a professional fighter, but with little success. Jack Britton died in Miami, Florida, on March 27, 1963. He was 76.

PACKEY MCFARLAND—CROWNLESS CHAMPION.
McFarland came out of Chicago's Stockyard neighborhood and turned professional at 16. He lost only twice in a glorious career and both setbacks came in 1904, his first year. The two fighters who beat him—Dusty Miller and Patsy O'Brien—are long since forgotten. Packey was not only popular and a big draw, but also a smart businessman. When he retired in 1913, he had saved $300,000. McFarland made a one-fight comeback in 1915 to face the St. Paul Phantom, Mike Gibbons, who was just as classy and clever as Packey. They drew a huge gate at Brighton Beach in Brooklyn, New York, and the fight was a dead-even contest. Packey then became a successful partner in a brewery and in a bank in Joliet, Illinois. He also headed up the Catholic Youth Organization and served on the Illinois Boxing Commission. Packey unwisely put on a lot of weight after his retirement and died of a heart condition on September 23, 1936. He was just 47.

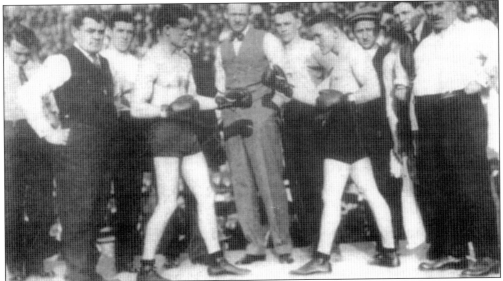

PACKEY GOES WEST. McFarland (left) squares off with "Harlem" Tommy Murphy on Novemeber 30, 1911, in San Fransico, California. With Chicago boxing in limbo, big time bouts like this, which Packey won in a 20-round decision, often took place on the West Coast. Packey had an uncanny knack of anticipating blows and rarely took a solid punch. And he could box and punch with the best of them. He tangled with the best lightweights and welterweights of his era and never got less than a draw. His opponents included Benny Yanger, Freddy Welsh, Jimmy Britt, Tommy Murphy, and fellow Stockyards resident Jack Britton. McFarland could never entice lightweight champ Battling Nelson into the ring, but Leach Cross, Owen Moran, and Matt Wells were willing, and proved no match for the handsome McFarland.

KID HERMAN AND JOE GANS— BEFORE THE TITLE BOUT.

Herman (right), born Herman Landfield, was one of the first in a long line of Jewish fighters who became contenders. He started his professional career in 1899 and quickly gained a big following in the ghetto. At age 16, he had fought most of the good Chicago lightweights and began touring the country, fighting the best boxers in their own hometowns. In 1905 and 1906, he defeated or drew with Young Erne, Abe Attell, Eddie Hanlon, Aurelio Herrera, and his chief Chicago rival, Benny Yanger. Herman finally was matched with Joe Gans for the world lightweight title and made a good showing before being knocked out in the eighth round. In his next bout he was badly beaten by Packey McFarland and retired.

BENNY YANGER—THE TIPTON SLASHER. Yanger was a tough little Italian who tangled with the best small men of his era. He started as a bantamweight and moved up to lightweight, beating Abe Attell, George Dixon, and Kid Broad en route. After being knocked out by fellow Chicagoan Packey McFarland, Yanger became a prominent referee. He is probably best remembered in Chicago for declaring challenger Mickey Walker the winner in the Irishman's 1926 middleweight title fight with Tiger Flowers. Yanger's controversial vote led the boxing commission to install two ringside judges to share the scoring with the referee.

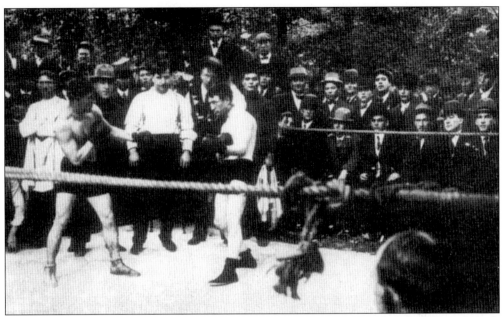

DANNY GOODMAN. Goodman (left) and Tommy Mowatt square off before their bout at Leafy Grove, Illinois, in 1914. Goodman, a talented lightweight who came out of the Maxwell Street ghetto, won by a knockout in the seventh round and captured a $5,000 side bet. Goodman made the boast that he fought 42 Black opponents, and beat them all. He later owned and operated the Veterans Inn, at 1031 S. Wabash Avenue, and The Wharf, at 55th and Lake Park Avenue, with his brother, Marv. Danny passed away on June 14, 1951.

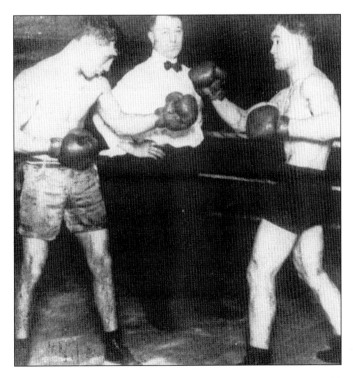

K.O. BROWN AND ROY GARDNER. Brown (left) and Gardner square off in East Chicago, before referee Dave Barry, on March 12, 1912. Brown was born George Contas in Sparta, Greece, and fought nearly all the top middleweights in the United States and Australia. Nobody could knock him out in close to 200 fights, until champ Mike O'Dowd did it in 1920. After retiring, George ran card rooms on Chicago's Southside. Roy Gardner also fought many of the top middleweights and had over one hundred bouts before retiring to become a steam fitter and headman of the Illinois VBA chapter.

HUGO KELLY. Born Ugo Micheli in Italy, Kelly started boxing in Chicago in 1899 and become one of the best middleweight contenders of his era. He fought and beat Philadelphia Jack O'Rien and fought to a draw with Tommy Burns, Billy Papke, Jack Sullivan and Tommy Ryan. Kelly beat champ Frank Klaus and earned a title fight in San Francisco with the immortal Stanley Ketchel. He put up a terrific fight in that bout until being KO'd in the third round on July 31, 1908. After retiring in 1912, Kelly got into the motion picture industry and became very successful in distribution of films in Chicago and Illinois.

TONY CAPONI. Caponi was another Chicago middleweight who fought at the same time as Hugo Kelly. He was also knocked out by Ketchel. Caponi started boxing in 1902 and held his own with Larry Temple, George Gunther, Billy Papke, and Eddie McGoorty. He fought the great Sam Langford twice, and also tangled a few times with future heavyweight champ, Tommy Burns. Tony retired in 1913.

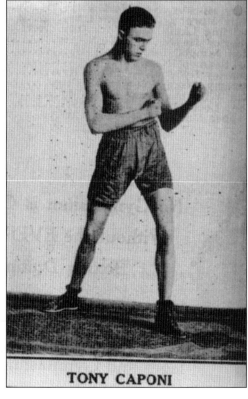

TONY CAPONI

CHARLIE WHITE—HOOKER FROM HELL. Charlie Anchowitz came to Chicago from England as a small boy. He was a victim of tuberculosis, which he overcame by exercise at O'Connell's Gym, and grew up fighting his way out of the Westside Jewish Ghetto. In 1906, the 15-year-old boxer changed his name to White and started fighting pro. In the next few years he knocked out most of the local boys and developed his great left hook, which was to become legendary. (They say once Charlie hit them with it, if they didn't go down, they did some funny things standing up.) He traveled all over the country, knocking out opponents in their hometowns, or losing close decisions. Champs such as Abe Atell, Johnny Dundee, Johnny Kilbane, and Jack Britton felt his power, and Charlie got a title shot against Freddie Welsh in 1916. He almost knocked the champ out, but Welsh rallied and won a 20-round decision. His next title bout was against the great Benny Leonard (who had KO'd Welsh for the title). White knocked Leonard out of the ring, but the champ was saved by his brother who shoved him back into the ring to beat the count. Then Benny went to work on Charlie and knocked him out in the ninth round. White fought on against the top men until 1923, and then quit the ring; and outside of a one-bout disaster in 1930, he thereafter devoted himself to a gym he opened in Chicago's Loop, which catered to wealthy women. Charlie prospered, moving to Los Angeles and trained movie stars. The punches from 170 tough fights caught up to him though, and he had to be committed to a sanitarium where he died on July 12, 1959. He was 68.

LOCAL CONTENDERS. Four of Chicago's top boxers from the early 1900s, seen here from left to right, are heavyweight Billy Stift, lightweight Danny Goodman, welterweight Morry Flynn, and welterweight Buddy Ryan.

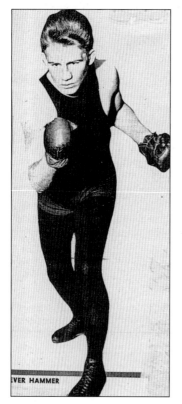

EVER HAMMER

EVER HAMMER. Hammer was just as tough as his name. He was the first of three Chicago lightweights to face the great Benny Leonard. The other two, Charlie White and Joe Welling, would make credible showings before being knocked out; but it was Hammer, in an outdoor fight in Kansas City in 1916, who gave Leonard the toughest fight of his career. Ever dished out terrific punishment in the early rounds and seemed on his way to a big upset when Benny rallied for a 12th-round knockout. Seven months later, Leonard would win the world 135-pound title. The knockout loss for Hammer was the only time in his career that he failed to go the distance, although he tangled with almost every top fighter at his weight.

JOE WELLING. Welling (left), a leading lightweight contender for many years, never got a chance to fight in his hometown of Chicago. He was of Bohemian descent and was a clever and courageous boxer who faced many of the top lightweights and welterweights of his era, including Jack Britton, Benny Leonard, and Johnny Dundee. His lightweight title bout with Leonard in New York's original Madison Square Garden in 1920 drew a then-record gate of almost $100,000. Joe gave Benny one of his toughest fights before going down for the seventh and last time in the 14th round. After retiring, Welling taught boxing at the N.Y.A.C and appeared in films.

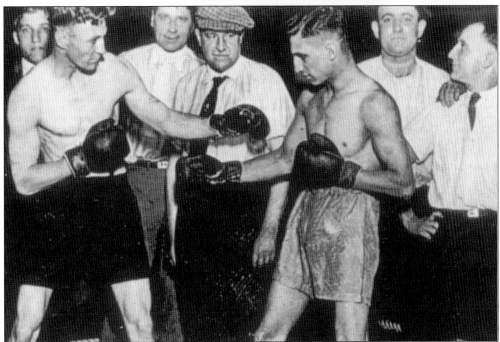

WELLING GOES EAST. Big-name Chicago boxers also headed to the East Coast while marquee bouts were all but banned in the city. Joe Welling (left) fought to a six-round no-decision with Lew Tendler (right) on July 14, 1919, in Philadelphia, Pennsylvania; a little closer to home, the two met up again for a 10-round no-decision the following year in Milwaukee, Wisconsin.

THE DEXTER PARK RIOT. Jim Mullin had by 1920 begun promoting 10-round fights in Chicago. These were "no decision" bouts, but the local sports writers would name their own winners in newspaper stories the next day and bets would be paid on their selections. Boxing was going so well that by 1923 Mullin was able to bring in title-holders and top contenders. In May of that year two champions appeared in a double main event at the Chicago Coliseum. Mickey Walker, the welterweight king, fought Cowboy Padgett; and Gene Tunney, the light heavyweight champ, boxed Jimmy Delaney. The American Legion served as promoter and the show was a huge success, with Walker and Tunney winning in impressive style.

A week later, Mullin promoted his most ambitious show to date: lightweight champion Benny Leonard (opposite page) against junior welterweight champ Pinkey Mitchell (above). Benny was considered the best pound-for-pound boxer in the world. Pinkey was a rising star and the brother of Ritchie Mitchell, who had been knocked out by Leonard. The match featured a great Irish vs. Jewish rivalry and fans packed the Dexter Park arena. Also in attendance were many societies ladies and gentlemen. Mullin had earmarked part of the gate for the Westside Boys Clubs.

The fight was uneventful until the last round when Leonard scored a pair of knockdowns. Referee Dave Miller stopped the match and declared Benny the winner on a technical knockout. Suddenly, Ritchie Mitchell jumped into the ring and slugged the referee. The attack prompted Hershey Miller, a notorious Chicago gangster and brother of Dave, also to enter the ring, followed by several of his gang, who beat Ritchie Mitchell mercilessly. Pandemonium broke loose as the hapless Mitchell was carried from the ring. The shocked society patrons fled for the exits, and boxing seemed once again dead in Chicago.

One good thing came out of the Dexter park riot: a young spectator at the fight named Andy Frain, after seeing all the chaos and carnage, got an idea for a trained force of men to keep order, assist patrons and take tickets, so he started the Andy Frain Ushers.

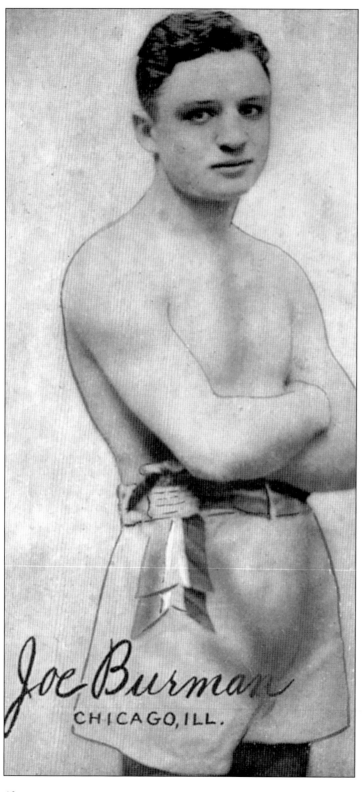

Joe Burman

CHICAGO, ILL.

JOE BURMAN—CHAMP FOR A DAY. Little Joe Burman was a terrific fighter and for many years had boxed all the top bantam and featherweights. In 1923, he fought bantamweight title holder Joe Lynch in Chicago's Dexter Park Arena and whipped him before 10,000 fans who paid $48,000 to see the Jewish ace score an upset. Lynch agreed to defend his title against Burman, and they were signed to fight on October 19, 1923, at New York's Madison Square Garden. The day of the fight, Lynch claimed a shoulder injury, but the New York Commission Doctors could find no injury and ordered Lynch to go through with the fight. Lynch and his manager refused and the commissioners declared Joe Burman the defending champion at the weigh-in. His new challenger was Abe Goldstein, a last minute substitute, who beat Joe that evening and was declared the new champ, thus ending the shortest reign in boxing history. When Joe retired he was a Liquor Salesman in Los Angeles, where he passed away of liver cancer in April of 1979. He was 81.

THREE

1926

Chicago Boxing Goes Legit

Despite the Dexter park fiasco, Jim Mullin continued his efforts to get the sport legalized in Illinois and he finally succeeded, seeing his dream come true in 1926. It was now legal to hold 10-round fights to a decision, and Mullin quickly scheduled the first world championship bout in Chicago history at Comiskey Park. On July 3, Sammy Mandell of Rockford, Illinois, took the lightweight title from Rocky Kansas of Buffalo, New York, on an easy 10-round decision. A crowd of more than 15,000—many from Sammy's hometown of nearby Rockford—paid $75,000 to see the contest, and boxing in Chicago was ready to enter its "Golden Age."

SAMMY MANDELL—THE ROCKFORD SHEIK. Sammy was born in Rockford, Illinois, and came to Chicago at an early age. His father was an Albanian and his mother was Italian. He was a protégé of Jack Blackburn and was one of the master boxers in ring history. Very fast and clever, he was known as the Rockford Sheik because of his good looks. He beat Rocky Kansas for the Lightweight title and defended it successfully against two of the greatest fighters of all time, Jimmy McLarnin and Tony Canzoneri. He lost the title to Al Singer in 1930, on a one-round knockout amidst rumors of a fixed fight and doping. Mandell fought on for several more years, retiring in 1934 after 187 fights. He trained and managed several boxers over the years. Samuel Mandell died in 1967. He was 63 years old.

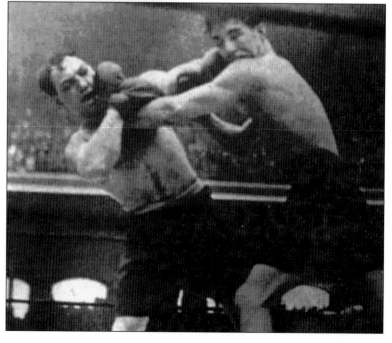

FIRST LEGAL BOUT IN CHICAGO. Mandell (right) defeated Rocky Kansas for the lightweight title at Comiskey Park on July 3, 1926. (Photo courtesy of Steve Compton.)

42

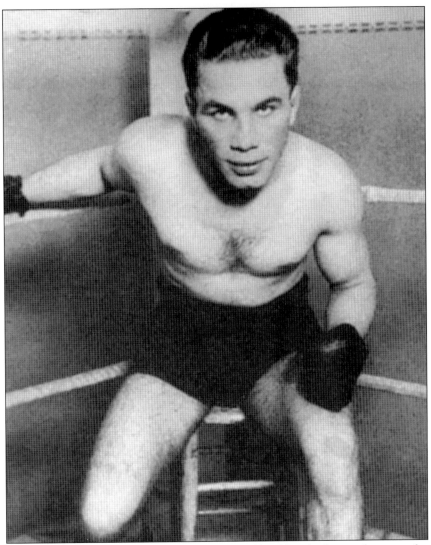

EDDIE SHEA—TANKING FOR THE CHAMP? Little Eddie Shea had everything it takes to be a champ. He was colorful and could punch with either hand. But in his bantamweight title shot in New York in 1925 he was knocked out for the only time in his career by Charley Phil Rosenberg, a fighter who could barely break an egg. When Eddie went out in the fourth round of a fight that looked phony to everyone who saw it, there were allegations that Shea and his manager had been threatened by New York gangsters. Rosenberg's manager was the notorious tough guy, Champ Segal. Betting patterns on the match were unusual and gamblers reportedly cleaned up. Even the New York Athletic Commissioner, Bill Muldoon, called the match an "outrageous fake." Nevertheless, Shea went on to be a contender in the featherweight division and fought and beat many of the best. He defeated champions like Benny Bass, Fidel La Barba and Chalky Wright, but all in non-title fights. He finally got another chance at a title in 1932 but lost a 10-round decision to the great Kid Chocolate. Shea, whose real name was Edward Donofrio, retired in 1933 and went into the saloon business. When World War II came, he served three years in the U.S. Army. Eddie later managed the Strand Hotel Bar off 63rd and Cottage Grove on Chicago's Southside, and he passed away in his room at the hotel in February, 1947. He was just 42.

WOLCOTT LANGFORD—BLACK, BLIND, AND BROKE. The old black man who sold tip sheets and newspapers outside Hawthorne Race Track was a fixture. He wore a sign that said he was blind, that his name was Walcott Langford, and that he had been a fighter in the 1920s. Some thought he was the legendary Sam Langford, who was also blind and who was supposedly Walcott's uncle. But most fight fans knew the real story, and they were happy to help Walcott make a living at the tracks and outside the fight arenas. They knew he had been one of the best young fighters to come out of the city's amateur ranks, winning some 150 bouts, most by knockout. As a professional, Walcott put together a good win streak and quickly became a fan favorite. When his bout with fellow Chicago knockout artist Shuffles Callahan drew a large gate and Langford scored a KO, promoters decided to import some of the world's best middleweights to exploit his popularity. But while he had been able to hold his own with local terrors like Tiger Roy and Sunny Jim Williams, he was no match for contenders like Dave Shade, Jack McVey, and Jock Malone, who handled him easily and dished out some real punishment. He started losing more than he won, and at the same time began to experience eye trouble. Finally he couldn't pass the athletic commission's exam and was forced to retire. Walcott Langford went blind soon after, and put on dark glasses and began wearing his sign. He was a familiar and well-liked figure. He died in August of 1972 on Chicago's Southside.

44

MIKE DUNDEE. Mike was a tough, local featherweight contender. He was managed by Al Capone in the early 1920s

GLOBETROTTER DAVE SHADE. Shade was one of the most popular fighters to box in Chicago. Although he hailed from California, he was a big favorite with the Irish fans in the Windy City. He was considered an "uncrowned champion" in the welterweight and middleweight divisions during the 1920s and beat many of the top fighters in almost 200 fights around the world. He was difficult to hit solidly and could outbox and outfight almost anyone near his weight. Shade also had a penchant for big cigars and for slugging cops when he'd had a little too much to drink.

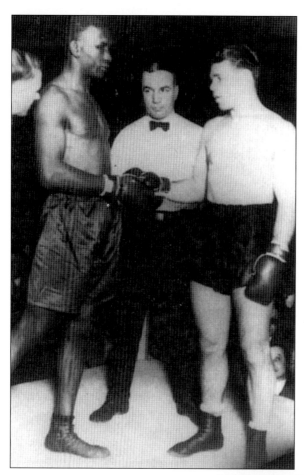

TIGER FLOWERS—ROBBED AT THE COLISEUM. Flowers (left) defended his middleweight championship against former welterweight king Mickey Walker at the Chicago Coliseum on December 3, 1926. Walker, one of the greatest fighters in ring history, got an early Christmas present that night when referee Benny Yanger declared him the winner. Although he had floored Tiger twice during the 10-rounder, he was thoroughly outboxed by the light-hitting Tiger, and the crowd was stunned when the decision was announced. Yanger defended himself by maintaining that Flowers had hit repeatedly with an open glove and that Walker had forced the match with his aggressiveness. The Illinois Boxing Commission disagreed, and ruled that henceforth there would be two ringside judges to render decisions along with the referee. The commissioners also mandated that Walker must make his first title defense against Flowers. That was not to be, however, as Tiger died on the operating table in 1927 while undergoing eye surgery.

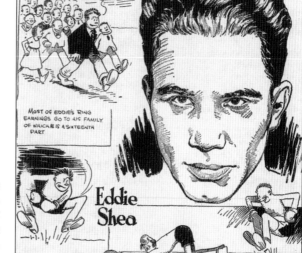

EDDIE SHEA—FAMILY MAN. This contemporary cartoon comments on how Eddie—a "regular jumping jack in the ring"—was generous with his ring earnings, spending much of it on his large family.

RAY MILLER. Miller was another of the great Jewish boxers who graced the lightweight division in 1920s Chicago. He was a murderous puncher with his left hook and he had unlimited courage. Ray had already beaten most of the top contenders by 1928, when he scored one of boxing's greatest upsets by stopping Jimmy McLarnin in eight rounds. It was McLarnin's only knockout loss. Jimmy out-pointed Miller in their New York rematch, but Ray's reputation was made. He later became one of New York's most respected referees. Ray passed away on March 3, 1987, in Florida. (Photo courtesy of Mike Silver.)

BUD TAYLOR—THE TERRA HAUTE TERROR. Taylor was a tall bantamweight who did most of his fighting in Chicago, where he built a big following. He defeated several world champs, including Jimmy McLarnin and Tony Canzoneri, and held the 118-pound title until he could no longer make the weight. Tragically, two of his opponents, Frankie Jerome and Clever Sencio, died after being beaten by Taylor.

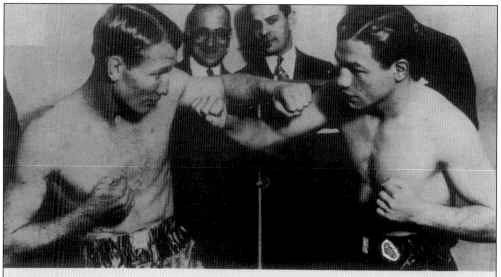

Chicago, Illinois, March 26, 1927. "Bud" Taylor, left, vs. Tony Canzoneri for open Bantam Title. 10 Rounds Draw, on June 24, 1927. Again with the title at stake over the 10 Round route Taylor won a great fight, and title, their 3rd and final bout held in N.Y.C. December 30th, 1927. Overweight, Title not at stake.
On August 21st, 1928 vacated the Title to move into Featherweight Division, along with Middleweight Champion Gorilla Jones. They were managed by one of the best in the business, Suey Welch.

TAYLOR AND CANZONERI. The two bantemweights pose at their weigh-in before one of their three battles. Taylor is on the left.

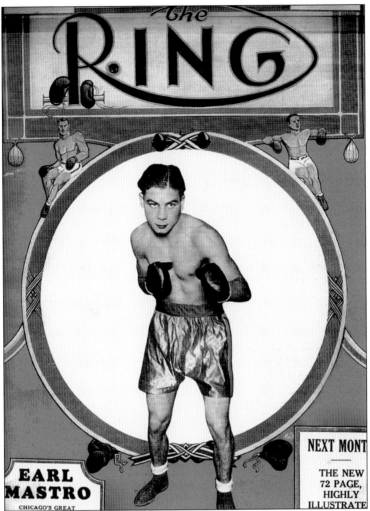

the RING

EARL MASTRO
CHICAGO'S GREAT

NEXT MONT

THE NEW
72 PAGE,
HIGHLY
ILLUSTRATE

HARD LUCK CONTENDER. Earl Mastro was a baby-faced youngster who took Chicago fans by storm in the late 1920s with his classy boxing skills. His brothers, Frank and Dick, also were competent fighters, but Earl was clearly the best. Mastro's rousing battles with Harry Dublinsky, Kid Francis, Fidel La Barba, and Bud Taylor made him the biggest draw in Chicago boxing. His first two meetings with La Barba were in Los Angeles, where he lost in 10 rounds in 1928 and out-pointed the former flyweight champ in 10 in 1929. In their August 7, 1930 rubber match in Chicago, they boxed to a 10-round draw. Earl also had three tough fights with Taylor, drawing with and then stopping the ex-bantamweight king in Chicago and later out pointing Taylor in a 10-rounder in Detroit. As a result he got a shot at the world featherweight title on November 4, 1931, facing Battling Battalino before a sellout crowd in Chicago Stadium. After 10 exciting rounds the decision went to Battalino, although many in the crowd thought Mastro deserved the nod. Mastro's luck really ran out the next year, at a time when he seemed a cinch for another championship match. In a tune-up bout in Sacramento, California, against Varias Milling, Earl suffered a detached retina that ended his boxing career at the age of 23. Mastro then turned to Vaudeville and did a song and dance act with his talented wife Madeline. And his brothers turned to writing. Frank became the boxing scribe for the Chicago Tribune while Dick compiled boxing record books and was also a promoter and annoucer. Earl (born Verele Maestro) died in Frazier Park, California, in December 1993. He was 85.

TUNNEY AND DEMPSEY. With big time boxing back in the Windy City, Chicago began to attract some of the biggest names in boxing. Gene Tunney (left) and Jack Dempsey (right) met at Chicago's Soldier Field (*below*) for the title. The bout drew record heavyweight gate receipts of over $2.5 million. Promoter Tex Rickard is pictured in the middle inset below.

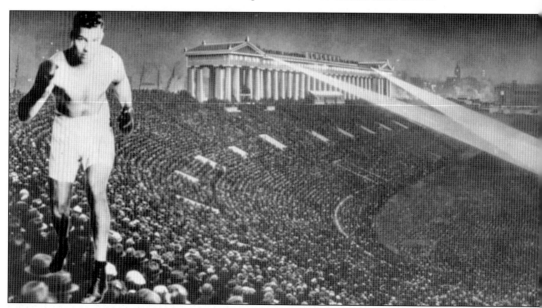

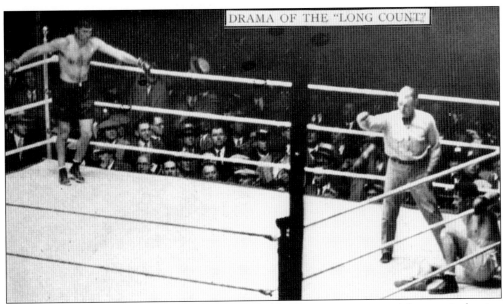

The Long Count. The "Long Count" was probably the most controversial event in boxing history. Gene Tunney (right), the champion, was winning easily before the largest paid attendance in the sport's history when former champ Jack Dempsey caught him with a flurry of punches and knocked him down in the seventh round. Referee Dave Barry ordered Dempsey to a neutral corner (as dictated by the rules), but Dempsey stood over the fallen Tunney for several seconds before complying, and timekeeper Paul Beeler had counted 18 by the time Gene got to his feet and boxed his way out of trouble. Tunney had no problem the rest of the way and even floored Jack in the eighth round. He retained his title on a ten round decision on that night in 1927, but fight fans ever since have wondered, "Could Tunney have gotten up within the 'usual' ten seconds given to a floored boxer?"

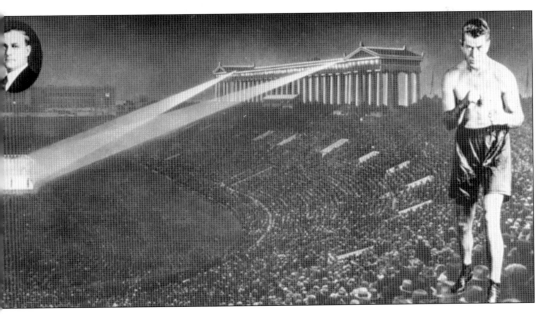

SUNNY JIM WILLIAMS. Sunny was so good that he couldn't make a living by boxing in America. He had to go all the way to Australia to get fights. Later, however, he returned to Chicago and became a well-known trainer. Bob Satterfield was one of his protégés.

JOEY MEDILL. A smart lightweight, Medill was another good Jewish fighter from the Westside. He was managed by Sam Pian and Art Winch. He started Davy Day out in Chicago boxing.

BABY FACE KO'S THE KID. Louis "Kid" Kaplan (left) squares off against Baby Face Jimmy McLarnin on October 18, 1927. Jimmy got off the floor and knocked out Kaplan in the eighth round. It was the first time the Kid had been KO'd. McLarnin's jaw was broken in this fight, although Jimmy didn't learn about it until he visited his dentist several days later.

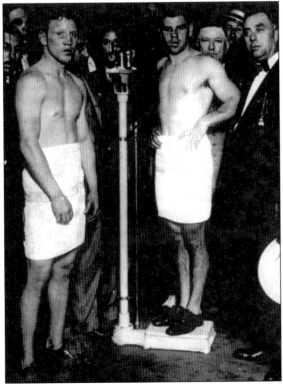

WALKER-HUDKINS. Middleweights Ace Hudkins (left) and Mickey Walker fought a savage title fight at Comiskey Park on June 21, 1928, with Walker winning a close decision in 10 rounds. They met again a year later in Los Angeles, where Walker won by a wide margin.

53

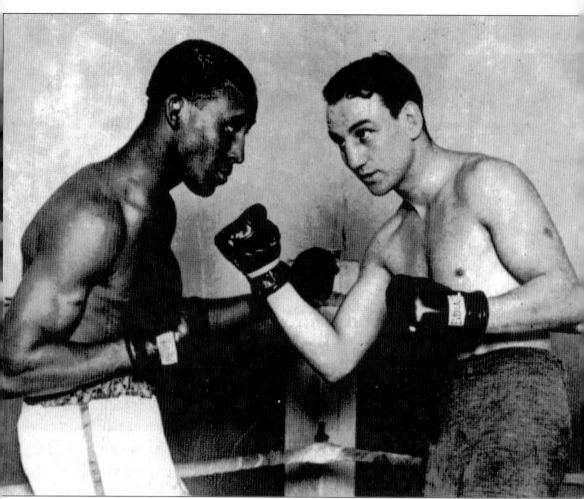

RIOT AT THE CHICAGO COLISEUM. One night in March 1929, Jackie Fields (right) and Young Jack Thompson were boxing for the vacant NBA welterweight title before a big crowd at the Chicago Coliseum. Fields, a great favorite with the local Jewish fans, was well ahead of his African-American opponent when somebody shouted a racial slur. When several black patrons began to advance on the perpetrator, a woman suddenly screamed, "He's got a gun," and panic swept the arena. Before calm was restored, a balcony railing gave way and many fans plunged to the floor below. Others were trampled as spectators tried desperately to reach the exits. One man had fallen to his death and 35 other fans were injured. Fields and Thompson finally resumed the contest and after 10 rounds Jackie was declared the new 147-pound champ. The fan who had pulled the gun was arrested and sent to jail for inciting a riot.

JACKIE FIELDS. Born Jacob Finkelstein, Jackie came out of the Maxwell Street ghetto and got his early boxing training form the great Jack Blackburn. He moved to Los Angeles with an older brother and became a protégé of another great teacher of boxing, George Blake. Jackie won the 1924 Olympic Featherweight Gold Medal at Antwerp and turned pro the same year. By 1929, he had beaten most contenders and won his first championship, the NBA welterweight title in Chicago. He would lose and regain the title in 1930 and 1932. He was a clever, hard-hitting boxer who was a good draw at the arenas. After losing an eye, Fields retired from the ring in 1933. He then went into the liquor business and later became an exuctive at the Riviera Hotel and casino in Las Vegas. He died in June of 1987, at age 79.

BATTALINO AND MASTRO. Battling Battalino (left) weighs in for his November 4, 1931 title defense against Earl Mastro at Chicago Stadium. Battalino retained the featherweight crown with a 10-round decision.

55

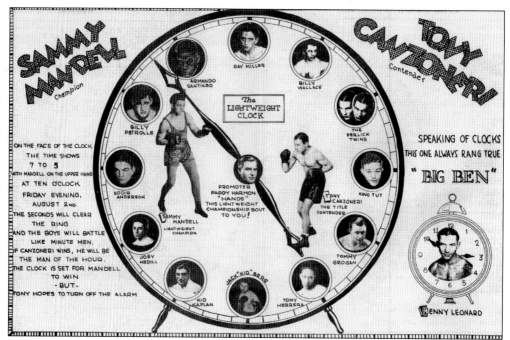

On the face of the clock the time shows **7 to 5** with Mandell on the upper hand at ten o'clock Friday evening, August 2nd. The seconds will clear the ring and the boys will battle like minute men. If Canzoneri wins, he will be the man of the hour. The clock is set for Mandell to win — BUT — Tony hopes to turn off the alarm

The LIGHTWEIGHT CLOCK

Speaking of clocks this one always rang true "BIG BEN"

Promoter Paddy Harmon "Hands" this lightweight championship bout to you!

(clock labels: RAY MILLER · ARMANDO SANTIAGO · BILLY WALLACE · BILLY PETROLLE · THE PERLICK TWINS · EDDIE ANDERSON · SAMMY MANDELL LIGHTWEIGHT CHAMPION · TONY CANZONERI THE TITLE CONTENDER · KING TUT · JOEY MEDILL · TOMMY GROGAN · KID KAPLAN · JACK "KID" BERG · TONY HERRERA · BENNY LEONARD)

CANZONERI AND MANDELL. On August 2, 1929, Tony Canzoneri met Sammy Mandell in Chicago for the lightweight title. Sammy won a 10-round decision.

STOCKYARDS HAROLD SMITH. Harold, who grew up "back of the yards," was a scrappy little Irishman who fought and beat several world champions, but never with the title on the line. Among the titleholders he defeated were Bud Taylor, Joe Lynch, and Charlie Phil Rosenberg. Smith had two huge cauliflower ears and was easily recognized in later years outside Readers Drug Store at 61st and Ellis Avenue, where he sold newspapers.

56

TIGER MAN. Roy "Tiger" Williams was a good all-around fighter who beat many of the top middleweights of the 1930s, including Gorilla Jones, Sammy Slaughter, and Patsy Perroni. He was handled by Joe Glaser, who also managed Louie Armstrong and other show biz greats.

LOUGHRAN AND WALKER. Tommy Loughran (left) met Mickey Walker (right) in Chicago for the lightheavyweight title. The bout opened Chicago Stadium on March 28, 1929. Loughran won the 10-round decision to retain the title. Walker's manager, wily Jack Kearns, had gotten the best of the contract negotiations. He and Walker wound up with the lion's share of the money, which totaled over $185,000 at the gate, and with Mickey's 160-pound title still intact.

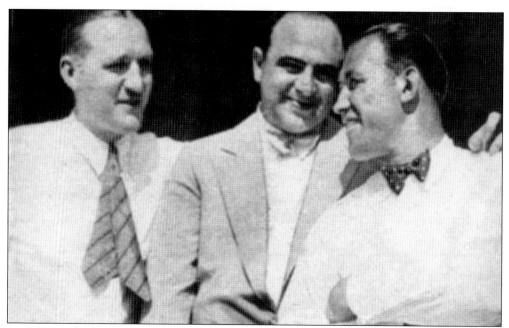

AN ALIBI. Jack Sharkey (right) poses with Al Capone (center) and sportswriter Bill Cunningham (left). This picture was taken in Miami Beach, Florida, on February 13, 1929. (The next morning in Chicago, the St. Valentine's Day Massacre occurred.) Sharkey, who was training for his bout with Young Stribling, would win the heavyweight championship in 1930. Al Capone was a big boxing fan who had financial interests in several good Chicago fighters, including Mike Dundee and Paul Dazzo. Capone, who threw a two-day party at the time of the 1927 Dempsey-Tunney fight at Soldier Field, often bought hundreds of tickets to help out promoters and loaned money to almost any manager or fighter who was down on his luck. He never tried to cut in on anybody and was considered a true "sport" in Chicago boxing circles. Capone paid for and gave away over a thousand tickets to the Jock Malone-Tiger Flowers bout at East Chicago in 1925. Al helped Barney Ross get started.

Johnny Torrio. Capone's boss, Torrio managed contender Kid Murphy and also promoted a few fights in his early years in Chicago. Torrio was also "okay" with the sporting and boxing crowd.

HARRY DUBLINSKY—THE CHICAGO BUZZ SAW. Harry was one of 21 children born to Polish parents and raised on Chicago's Southwest side. He started boxing in 1926 and worked his way up in the small clubs that flourished when the sport was legalized. Young Dublinsky fought all of the top featherweights and lightweights in Chicago, including Henry Leonard, Earl Mastro, and future champion Barney Ross. He boxed an eight-round draw with Ross in November 1930 and then scored a victory over top-notchers Bruce Flowers, Tommy Grogan and, in a non-title fight, world junior welterweight champion Johnny Jadick. Harry's winning ways got him ranked in the top lightweight contenders, but by then he was growing into a full-fledged welterweight. In 1934, he won and lost in two exciting fights with Tony Canzoneri, becoming a big draw in New York because of his aggressive style of fighting. Still, he never got a shot at the title and after several losses in 1936 he retired from boxing and opened a saloon in his old Chicago neighborhood, near 47th and Damen. Harry died in April of 1977.

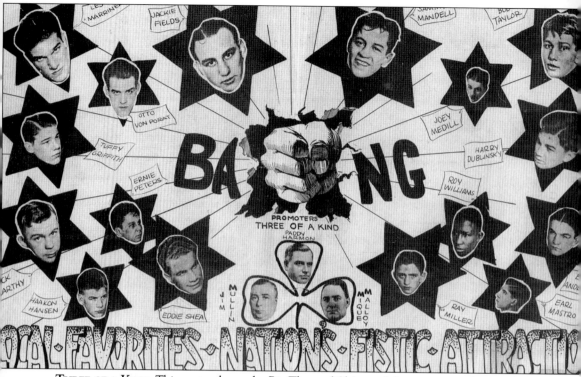

THREE OF A KIND. This poster shows the Big Three of Chicago fight promoters, along with some of their top talent. The trio of Irishmen are Jim Mullen, Paddy Harmon, and Mique Malloy.

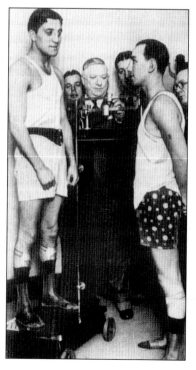

JACKIE FIELDS AND VINCE DUNDEE. Dundee (left) weighs in for a non-title fight with welterweight champ Jackie Fields on October 2, 1929. Just 71 days earlier, in Detroit, Jackie had captured the title, on a foul, from Vince's brother, Joe Dundee. Fields out pointed Vince in 10 rounds and beat him again the following January.

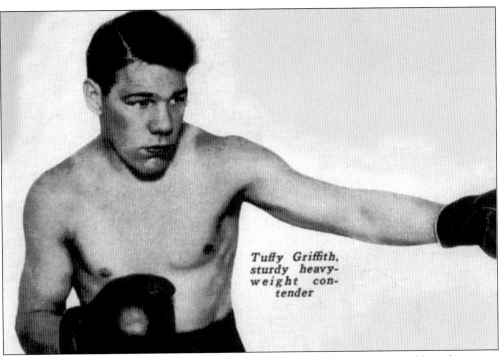

Tuffy Griffith, sturdy heavyweight contender

TUFFY GRIFFITHS. Gerald Ambrose Griffiths, aka. Tuffy Griffiths, hailed from Sioux City, Iowa, but took Chicago fans by storm in the Roarin' Twenties. Although he weighed only about 175 pounds, he took on many of the top heavyweights of his era—and beat most of them. He was a hard hitter and as game as they come. He made a lot of money and after retiring opened a successful saloon near Wrigley Field.

LARRY JOHNSON. Johnson, another light-heavyweight who was a hard man to beat, could box and was a power puncher. He was a stable mate of Tuffy Griffiths, both of them being managed by Westside Jack O'Keefe. (Photo courtesy of Bob Carson.)

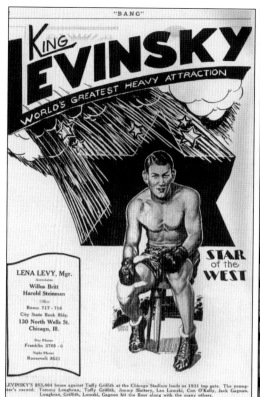

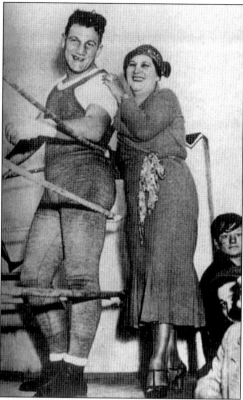

KING LEVINSKY—CLOWN OF CHICAGO BOXING. Levinsky, also known as "Kingfish," was born Harris Krakow but took his nickname in honor of the family's seafood business on Chicago's Maxwell Street. He was an improbable fighter, but he caught on with the city's boxing fans. The heavyweight Kingfish was big and strong, had stamina and a powerful right hand. But he couldn't box much and had virtually no defense. The first of his eight career managers was his flamboyant sister, known as "Leapin' Lena" (above, right), a source of colorful anecdotes for sportswriters. He fought most of the top heavyweights of his time, winning as many as he lost, and he almost always put on a good show. Levinsky gained national prominence by manhandling ex-champ Jack Dempsey in an exhibition match that broke the Chicago Stadium attendance record; and in 1932, he twice went the distance with future champion Max Baer. But in 1934, soon after Baer had beaten Primo Carnera for the title, the Kingfish suffered his first knockout loss in an exhibition with Max in Chicago. In 1935, a young Joe Louis literally terrified Levinksy and stopped him in the first round at Comiskey Park. That loss, and the Kingfish's sad performance, pretty much ended his welcome in Chicago, although he fought on elsewhere for several more years. Unhappily, the $250,000 he had earned in the ring was lost in bad investments and bad marriages. Undeterred, Levinsky turned to selling neckties. He began showing up at stadiums and racetracks carrying a valise filled with neckwear. Few could resist his sales pitch, which was delivered as he wrapped a tie around his customer's neck as if to perform strangulation. But the Kingfish was always ready with a joke about his career and most of his customers felt good about helping out the good-natured ex-pug. He passed away on September 30, 1991.

FOUR

Ross, Louis and Zale...
Golden Age of Chicago Boxing

Barney Ross, the most popular Chicago boxer, rose like a shooting star in the early 1930s. He was followed by Joe Louis, who became great in Chicago. By the end of the decade, local boxer Tony Zale began his climb to the title. Also prominent during this era were Davey Day, Larry Johnson, "King" Levinsky, Tuffy Griffiths, and many others who packed local arenas.

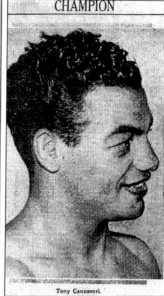

BARNEY ROSS—RING HERO AND WAR HERO. Ross—seen here as a young junior welterweight *(left)*, in a headline before his lightweight title bout with Tony Canzoneri *(center)*, and as a celebrity on the cover of *The Ring* magazine *(right)*—was one of the best boxers the city ever produced. In 1929, a 19-year-old Jewish kid from Chicago's Westside ghetto named Beryl David Rosofsky won the Golden Gloves title in Chicago and then the Inter-city championship in New York's Madison Square Garden. His father had been killed in a recent holdup in the family store, so the youngster, who called himself Barney Ross, turned professional that same year in order to support his family. By 1933, he had used his quickness and flashy skills to defeat some of the world's top lightweight contenders and gain a shot at champion Tony Canzoneri. On June 23 of that year, before a capacity crowd in Chicago Stadium, Ross won a close and exciting decision over the great Canzoneri, and with it Tony's lightweight and junior welterweight titles. Barney Ross won a close and exciting 10-rounder over Tony Canzoneri to take Tony's world lightweight championship on June 23, 1933. The following September, the two warriors were rematched in the Polo Grounds in New York and again Ross used dazzling boxing and accurate punching to out point Canzoneri, this time over 15 rounds. After the impressive victory, which made Ross an overnight hero to New York's many Jewish fans, he relinquished the lightweight crown and decided to pursue Jimmy McLarnin's welterweight title. McLarnin had knocked out the great Benny Leonard and many other top Jewish boxers.

Barney successfully defended the 140-pound junior welterweight championship three times in early 1934 before facing McLarnin on May 28, in the Long Island (NY) Bowl for both that title and Jimmy's 147-pound crown. It was the first of three sensational 15-round fights between the two, with Ross winning the first, losing the second in the same arena on the following September 18, and then regaining the championships in their final meeting on May 28, 1935 in New York City. The rivalry thrilled the nation's Jewish and Irish fans, but many

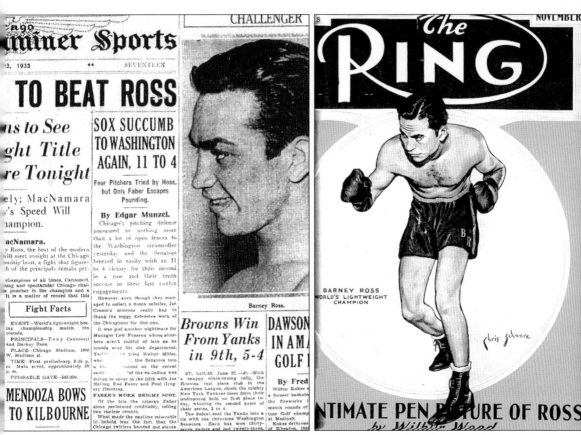

TO BEAT ROSS

boxing authorities believe the torrid matches took something out of both boxers, who never again seemed quite the same.

McLarnin had only three more fights and retired in 1936. Ross, who gave up the junior welter weight title after his final victory over Jimmy, defended the welterweight crown once in 1936 and once in 1937, but spent an increasing amount of time in night clubs and at the race track. On May 31, 1938 in the Long Island Bowl he took a bad beating from the great Henry Armstrong over 15 difficult rounds and quickly announced her retirement.

Ross, who loved the bright lights and wanted to be where the action was, opened a saloon in Chicago and also exploited his likeable personality in public relations work. But somehow he managed to squander most of his money, although he remained a very popular ex-champ.

When America entered the war against Japan after the attack on Pearl Harbor, Barney joined the U.S. Marine Corps and soon found himself in the middle of the assault on Guadalcanal. There he saved three Marine buddies during a bloody night of fighting, during which he killed more than 20 of the enemy and was seriously wounded. He was awarded the Silver Star and several other medals for heroism. But he became addicted to morphine while recovering, although he returned home and sold war bonds and went on USO tours.

At the end of the war, he drifted from job to job while trying to hide his addiction, but finally had himself admitted to the U.S. hospital in Lexington, New York. He came out cured in 1946. In 1957, a motion picture, *Monkey on My Back*, based on Barney's own book about his career and addiction, was released by United Artists; Ross, however, hated the film and filed a lawsuit against the producers. He won an out-of-court settlement. Ross, who never lost his love for boxing, died of throat cancer in 1967 at the age of 58. He was laid to rest in his beloved hometown of Chicago.

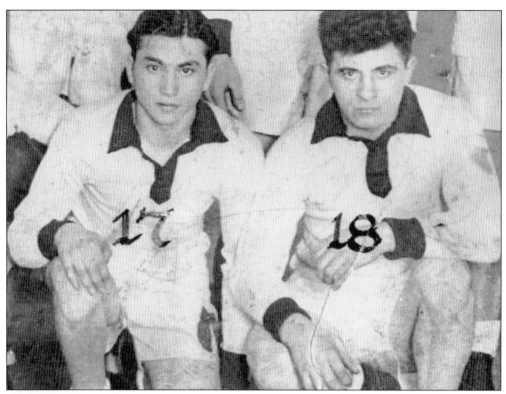

Ross and Fosco. A very young Barney Ross (left) is seen with Nick Fosco, his Inter-city Golden Gloves teammate, in 1929. (Coutesy of Tony Fosco).

"Kid" Howard Carr. Famous proprietor of Kid Howard's Gym, Carr is seen with one of the fighters he managed, Marty Simmons, a good journeyman middleweight.

CECIL "SEAL" HARRIS. Harris was a large heavyweight who could box with the best of them. and make an opponent look good, if he had to. He later became one of Joe Louis' sparring partners for the Primo Carnera fight.

DAVE MILLER. Chicago's top referee, and brother of the notorious Hershy and Maxie Miller, Dave was once shot by gangster Dion O'Bannion outside a Loop theater. He recovered.

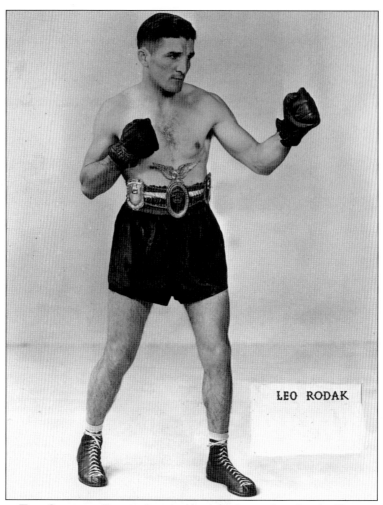

LEO RODAK

LEO RODAK—THE CHICAGO FLASH. Leo was born and raised in South Chicago. He was of Ukrainian descent, and came from an athletic family—his brother Mike was a six day bike racing champion. Leo joined the CYO at 16 and in 1931, 1932, and 1933 he won the Golden Gloves championships at flyweight, bantamweight, and featherweight, respectively. He won several inter-city and international titles also. Rodak turned pro in 1933 and in his first year beat the formidable Eddie Shea, Young Rightmire, and ex-champ, Tommy Paul. In the next few years, he won and lost decisions with the best feathers and lightweights in contention, like Tony Canzoneri, Wes Ramey, and Bushy Graham. Leo was one of the fastest men with his hands and footwork in the ring. He was not a big puncher and only had six knockouts in 117 professional bouts. He usually spotted his opponents weight but he could out box most of them.

In 1938, he beat Jackie Wilson, Freddie Miller, and Leon Efrati for the featherweight championship. Leo had to travel all over the country fighting the best fighters in their hometowns. He lost his NBA title to Joey Archibald in a close fight in Baltimore, Maryland, but kept busy the next few years and when World War II broke out he joined the Marine Corp. Rodak kept boxing while a Marine and had some classic battles with Willy Joyce and Henry Armstrong. His wife died young and he never got over the loss. He retired from the Ring in 1946 and went to work for the Cook County Forestry Dept. and trained boxers. Leo passed away in April of 1991. He was 77 years old.

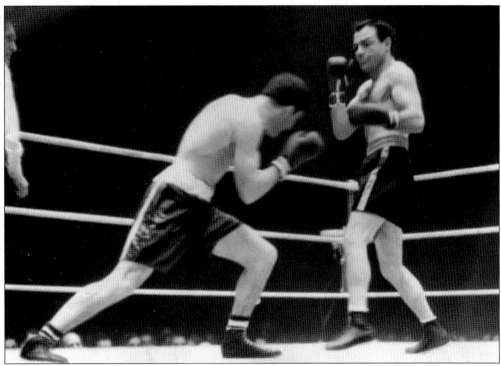

TONY TAKES LEO TO SCHOOL. A very young Leo Rodak gets a boxing lesson from triple champ Tony Canzoneri at Chicago Stadium on January 31, 1935.

FRANKIE "KID" COVELLI. A featherweight, Covelli fought all over the world against the best in their hometowns, and in 1938 he settled in Chicago. He fought here for the rest of his career, tending bar in Loop hotels after service in World War II.

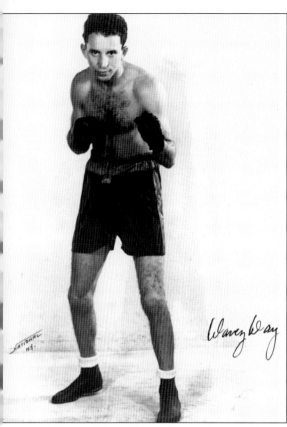 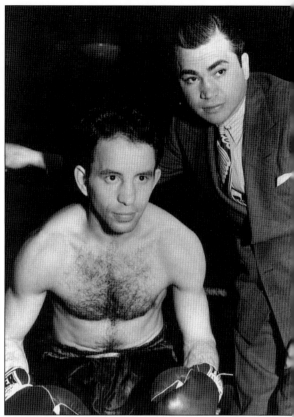

DAVEY DAY—LAST OF THE JEWISH GREATS. Day, born David Daitch, grew up on Chicago's Westside, a neighborhood that produced many of the city's best fighters. Unfortunately, the classy boxer-puncher was managed by Sam Pian and Art Winch, who also handled world welterweight champ Barney Ross (pictured with Davey, above right). Davey was rated at the top in two divisions—lightweight and welterweight—although he was always a 135 pouder. He beat a lot of the best in both divisions, men like Stan Loayza, Joe Ghnouly, Bobby Pacho, Jimmy Garrison, and Enrico Venturi. Davey also beat local stars Pete Lello, Nick Castiglione, Frankie Sagilio, and Roger Bernard. He fought champ Lou Ambers in a non-title fight in New York and was robbed of the decision. In the late 1930s, when Barney Ross was nearing the end of his career, Davey might well have beaten him. However, since it was not possible for fighters with the same manager to box each other, Day had to stand by while Ross lost the title to the great Henry Armstrong in 1938. When Davey got his shot at the 147-pound title on March 31, 1939, in Madison Square Garden, it was against Armstrong, who was then at his peak and who held both the lightweight and welterweight crowns. After a grueling and bloody match, Hammerin' Hank was declared the winner by knockout in the 12th round. Day bounced right back in his next fight and stopped Pedro Montanez, the leading welterweight contender, in a bout that was supposed to decide Armstrong's next title opponent. But Davey was disappointed when Montanez got the match because he was a fan favorite in New York. Davey dropped back down to lightweight and beat Sammy Angott in 12 rounds at the Chicago Stadium. They were rematched in Louisville for the vacant 135-pound title and Angott won a very close 15 rounder. Davey retired after being stopped by future champ Bob Montgomery and opened a luggage store in the Loop. He also operated a veteran's taxi for many years. Davey Day passed away in October of 1990. He was 78.

JIMMY CHRISTY. Jimmy, of the CYO, won the Golden Gloves and became a ranked featherweight as a professional. Tragically, he was killed in World War II.

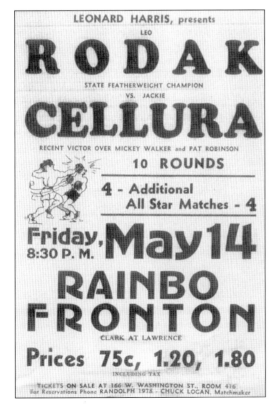

LEONARD HARRIS, presents

LEO

RODAK

STATE FEATHERWEIGHT CHAMPION

VS. JACKIE

CELLURA

RECENT VICTOR OVER MICKEY WALKER and PAT ROBINSON

10 ROUNDS

4 - Additional
All Star Matches - 4

Friday, May 14
8:30 P. M.

RAINBO
FRONTON

CLARK AT LAWRENCE

Prices 75c, 1.20, 1.80
INCLUDING TAX

TICKETS ON SALE AT 166 W. WASHINGTON ST., ROOM 416
For Reservations Phone RANDOLPH 1978 - CHUCK LOGAN, Matchmaker

RAINBO ARENA. This local venue operated off and on from the 1930s through the 1950s. The arena hosted many of the city's top boxers.

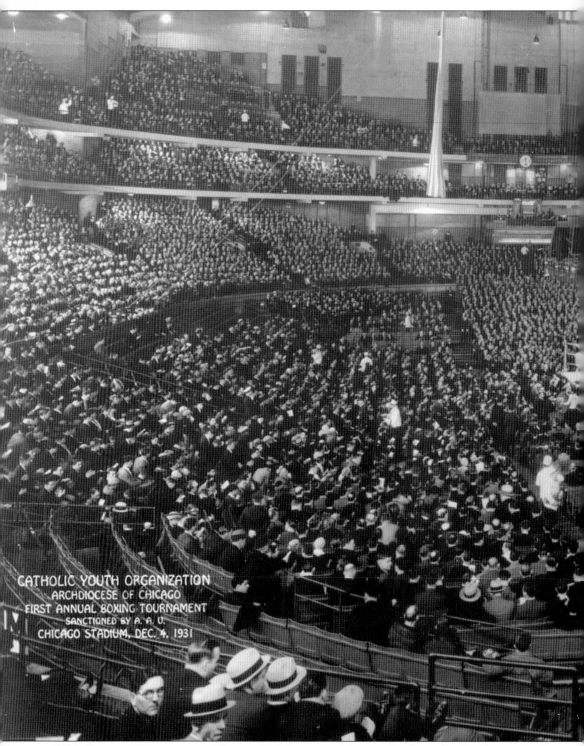

CYO BOXING TOURNAMENT. This packed house at Chicago Stadium for the first annual Catholic Youth Organization Boxing Tournament on December 4, 1931, was typical of the

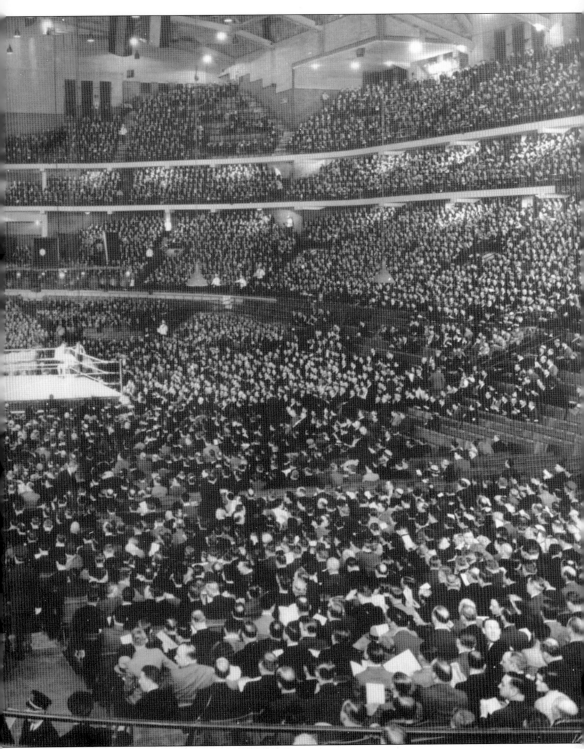

CYO tourney, which ran annually through 1997.

Ross Gets a Title Shot. Barney Ross (left) watches Billy Pettrole on the scales during the weigh-in for their March 22, 1933 bout at Chicago Stadium. Ross beat Pettrole easily that night on a 10-round decision to earn a title shot with Tony Canzoneri, who looks on (far right) as the contenders weigh-in. Commissioners Packey Mcfarland (center) and Joe Triner (second from right) are also present. (Photo courtesy of Chuck Hasson.)

THREE CHAMPS AT THE '33 WORLD'S FAIR. Battling Nelson (left) and Johhny Coulon boxed an exhibition at the 1933 World's Fair in Chicago. That's the great Jack Johnson refereeing.

EDDIE PLIQUE AT THE SAVOY A.C. Plique (left, front row), a popular Chicago promoter and announcer, is with Jack Johnson (middle), Homeboy McLain (standing over Jack's left shoulder), and a group of fighters training at the Savoy A.C. in the mid-1930s. (Photo courtesy of Dempsey J. Travis.)

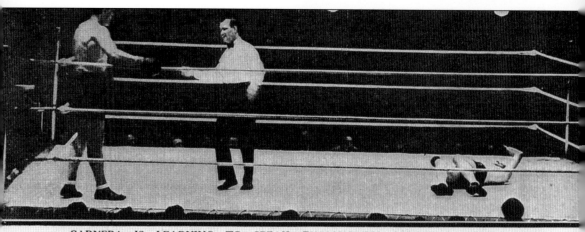

THE ITALIAN GIANT COMES TO CHICAGO. Primo Carnara, the "Italian Giant," was one of many international boxers who came to Chicago during boxing's golden age in the city. The above bout, a fourth-round knockout of heavyweight Jack Gross, took place at Chicago Stadium. The 6-foot-7, 270-pound Carnera was the first Italian to win the heavyweight title, in 1933. He would later be stopped by Max Baer in 1934 and, in a six-round knockout at New York's Yankee Stadium in 1935, by another future heavyweight champ to achieve greatness in Chicago—Joe Louis.

JACK BERG AND TONY CANZONERI. The Berg-Canzoneri fight was one of many title bouts of the era promoted at Chicago Stadium. Canzoneri KO'd Berg in the third round.

76

MAX MAREK—THE MAN WHO BEAT JOE LOUIS. Handsome Max Marek (right), who out pointed Joe Louis in the AAU light heavyweight finals in Boston in 1933, was not only a good boxer but also one of the great characters in Chicago boxing. The charismatic Polish-American, an alumnus of Notre Dame University, won the Chicago and Inter-City Golden Gloves and the international amateur 175-pound crown. He became a professional in 1935 and compiled an impressive record, finally earning a fight with light-heavyweight champion John Henry Lewis (left) at Comiskey Park on July 10, 1936. But Lewis out pointed Max in 10 rounds. After a career of some 40 matches, Marek retired from the ring. When World War II came, he joined the U.S. Coast Guard and served as a boxing instructor who also staged fight cards. Upon discharge, he opened the famous Hind Palace at 41st and Halstead on Chicago's Southside. The Bar was unique in that instead of mounting the heads of big game animals on the walls, Max displayed their posteriors. A relentless "ribber," he later opened Max Marek's Cafe on West 63rd Street, where he placed a sign in his window that read "Food is Recommended to Duncan Hines." Hines, the well-known gourmet and food critic, sued Marek and Max was forced to take down the placard. Marek tried his hand at pro wrestling in the 1950s, billing himself as the "Polish Pride." Max died in Palmdale, California in May of 1977. He was 63 years of age.

1934 GOLDEN GLOVE TEAM. Team members, from left to right, are Patsy Urso, Troy Bellini, Al Nettlow, Frank Bojack, Phil Kennelley, Danny Farrar, Billy Treest, Joe Louis, and Otis Thomas. Louis was arrested on a phony charge to keep him out of the International Golden Gloves bouts, and was released too late to box that night. Also, he hurt his hand and could not compete in the inter-city tourney later that year. Phil Kennelly became a well-known actor.

JOE LOUIS GETS MARRIED. Marva Trotter was a secretary on Chicago's Southside. She and Joe Louis got married in New York City on September 24, 1935, the same day that Joe knocked out former champ Max Baer in four rounds. The couple later got divorced, remarried, and then finally divorced again in the early 1950s.

JOE LOUIS AND CHARLIE RETZLAFF—WEIGH-IN. Louis (on scale) and Retzlaff are seen here weighing in for their January 17, 1936 heavyweight bout in Chicago. That's an overweight Packey McFarland at left. Joe and Charlie were both big punchers, but Joe landed first and had another first round knockout. McFarland died of a heart attack later that year.

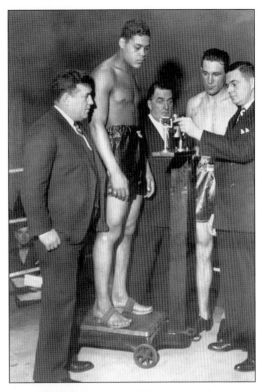

JOE CROWNS THE KING IN ONE ROUND. Both Kingfish Levinsky and Joe Louis were looking for an opening in their 1934 match at Comiskey Park. Joe found one and stopped Levinsky in the first round.

JACK BLACKBURN—GREAT FIGHTER, GREAT TRAINER. Blackburn (left) was once a great fighter himself, known as the "Phillie Comet" when he was the uncrowned lightweight champ in the early 1900s, but became more famous as the teacher and trainer of Joe Louis (right). He also taught local greats Bud Taylor, Sammy Mandell, and Jackie Fields, as well as Jersey Joe Wolcott. Jack was also a handy-man with a pistol or a razor, and was known as a bad drunk (notice the long scar on his cheek). He killed a couple of people and did a stretch in prison for manslaughter. He and Louis had a father-son relationship and called each other "Chappie." Just before the second Louis-Buddy Baer fight, Jack told Joe he didn't feel well and could not make it up the steps to work the corner. Joe said, "You will only have to climb the steps once tonight, old Chappie." He KO'd Buddy in one round. Not long after, Blackburn died, and 10,000 attended the service at First Baptist Church on Chicago's Southside. Joe Louis in his Army uniform led the mourners.

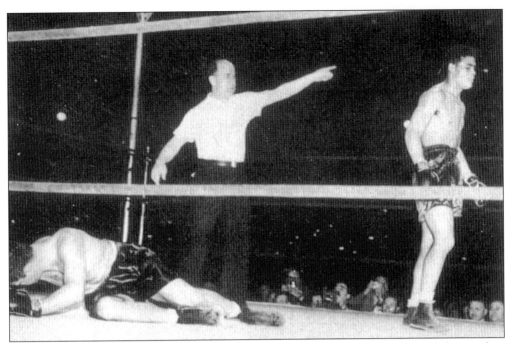

JOE LOUIS WINS THE TITLE. Louis knocked out Jimmy Braddock in the eighth round at Chicago's Comiskey Park on June 22, 1937. A game Braddock had Louis down in the first round but then took a bad beating. Jimmy said getting hit by Joe was like having "a light bulb explode in your face."

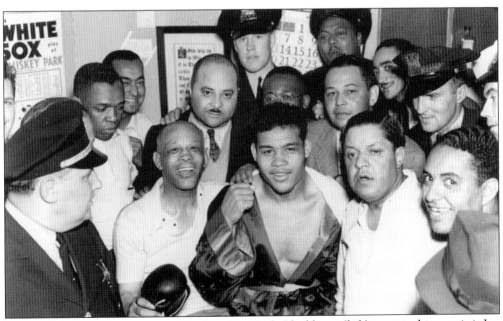

DRESSING ROOM AFTERWARD. That's trainer Jack Blackburn (left) next to his protégé, Joe Louis, who has just won the heavyweight title by knocking out Jimmy Braddock. Also seen are Joe's managers, John Roxborough and Julian Black (with arm around Louis). Joe would go on to defend the title 25 times and hold it for more than 11 years.

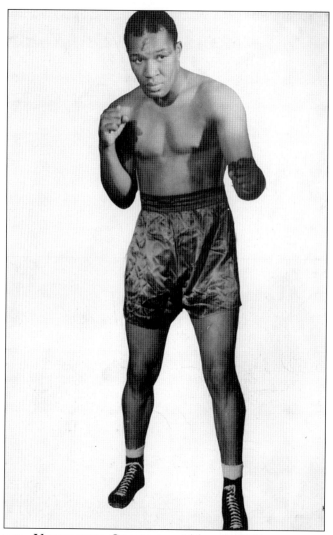

HOLMAN WILLIAMS—UNCROWNED CHAMPION. Although Williams was raised and started fighting in Detroit, he Moved to Chicago in the mid-'30s, around the same time as his stable mate and friend, Joe Louis. Holman fought out of and lived in Chicago for most of his life. He started boxing in 1932 as a pro and in 1935 knocked out Baby Tiger Flowers at Comiskey Park to win the Colored Lightweight Championship. Later in his career he won the Colored middleweight title with a 15-round decision over the feared Charlie Burley at New Orleans in 1942. These fights were as close as he would ever come to winning a boxing title because no champion would give this Master Boxer a shot; not just the White champs, but also such great Black champions such as Ray Robinson and Henry Armstrong. Holman fought all the top contenders in 30s and 40s in the 135, 147, and 160-pound divisions—and beat most of them. He squared off against men like Charley Burley, Cocoa Kid, and Eddie Booker who were also "uncrowned" Champs. He even fought and beat light-heavyweights Archie Moore and Lloyd Marshall when they were the most feared punchers in Boxing. He fought these men and other "untouchables" many times and for short money. In 1948, after almost 200 fights, Holman retired and trained boxers at the Savoy A.C. and Eddie Nichols' Gym. He moved to Akron, Ohio, in the late 1950s and started training boxers for a friend and became a porter at the Wonder Club Bar, where he died in a fire in the summer of 1967. He was 52 years old.

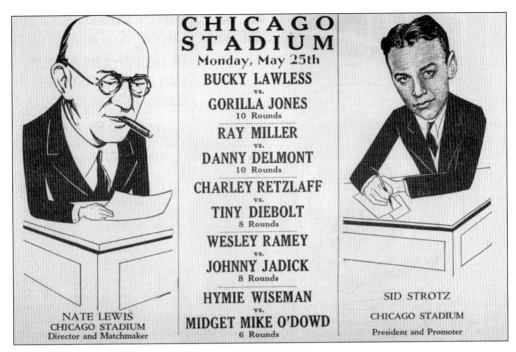

CHICAGO STADIUM

Monday, May 25th

BUCKY LAWLESS
vs.
GORILLA JONES
10 Rounds

RAY MILLER
vs.
DANNY DELMONT
10 Rounds

CHARLEY RETZLAFF
vs.
TINY DIEBOLT
8 Rounds

WESLEY RAMEY
vs.
JOHNNY JADICK
8 Rounds

HYMIE WISEMAN
vs.
MIDGET MIKE O'DOWD
6 Rounds

NATE LEWIS
CHICAGO STADIUM
Director and Matchmaker

SID STROTZ
CHICAGO STADIUM
President and Promoter

CHICAGO STADIUM— HOME OF MARQUEE MATCHES. This poster for a fight night at the Stadium charicatures Nate Lewis (left), the stadium's director and matchmaker, and Sid Strotz (right), president and promoter.

FUN AT THE GYM. Powerful right hand puncher Max Baer lifts local great Leo Rodak at Trafton's Gym in 1935.

NATE BOLDEN—HE FOUGHT THEM ALL. Nate was a member of the Savoy A.C. and won the Chicago and Inter-city Golden Glove championships in 1937. He turned pro the same year and was ranked near the top in the middleweight and light-heavyweight divisions for a decade. He fought Tony Zale four times, winning twice, and also beat Jake Lamotta. He fought Joe Maxim and Archie Moore, and uncrowned champs like Charley Burley, Jimmy Bivins and Lloyd Marshall. Nate even fought tough heavyweights such as Lee Savold, Curtis "Hatchet Man" Sheppard and Tony Musto. Bolden beat Oscar Rankins at White City Arena in 12 rounds on April 14, 1939, to win the Colored Middleweight Championship—his only title shot. He was a very fast and shifty boxer and had a good left hand. After retiring, Nate went to work for the Chicago Streets and Sanitation Dept. He trained several Golden Glove champs, including Craig Bodzianowski and Paulie Williams. Nate passed in August of 1991 at 74 years of age.

MARIGOLD GARDENS. The Gardens, with a capacity of 6,000, was one of Chicago's premier boxing venues of the era.

**MILT ARON—THE KING OF
MARIGOLD GARDENS.** Milt was a
rabbi's son from the teeming Westside
ghetto. He loved to fight and his
managers, Jack Begun and Benny Ray,
built him into a big drawing card. He
was a terrific puncher who never had
a dull fight. He would lose now and
then, but his fans never gave up on him
and believed he could be a champion.
Aron scored sensational knockouts
over Frankie Sagilio, Johnny Barbara,
and Jack "Kid" Berg; and in December
of 1939, he got off the canvas to score
a KO over Fritzie Zivic in one of the
best fights ever seen in Chicago. In
1940, *Ring Magazine* ranked him as
the number one contender for Henry
Armstrong's welterweight title. But
Milt then lost to Steve Mamakos and
Mike Kaplan and started to slip. After
some good wins the next year, he was
knocked out by Zivic in the ex-champ's
hometown of Pittsburgh, Pennsylvania.
It turned out to be Aron's last fight.
After a five-month battle with blood
poisoning, he died on March 6, 1942.
He was only 25.

FRANKIE SAGILIO

FRANK SAGILIO
vs.
MILT ARON

Marigold Gardens
817 Grace St. Chicago, Ill.

Monday, May 24th
**Another Great Show for this
Season**
(In case of rain—Show moved indoors)

CHICAGO'S 1937 NATURAL
Winner To Meet Barney Ross

Call for Reservations
Phone: Dearborn 4268

Wednesday, June 2nd
DAVEY DAY
vs.
JIMMY GARRISON

MILT ARON

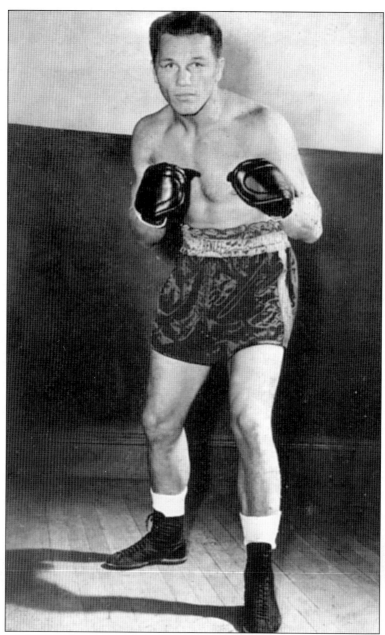

TONY ZALE—MAN OF STEEL. Born and raised in nearby Gary, Indiana, Tony Zale and his brothers all became boxers in their teens. Tony won the Chicago Golden Gloves in 1934 and turned pro the same year. He was a hard puncher who could take it, and had stamina but was not very skillful. Tony, whose real name was Anthony Florian Zaleski, became so discouraged during an in-and-out early career that he thought about giving up the game. During one stretch in 1934–35, he lost six of eight fights, after which he went to work in the steel mills and had only one bout over the next two years. But Zale's luck took a turn when he ran into the management team of Sam Pian and Art Winch. Winch taught him to go to the body and to shorten his punches. Tony started to win consistently and he began a march toward the middleweight title.

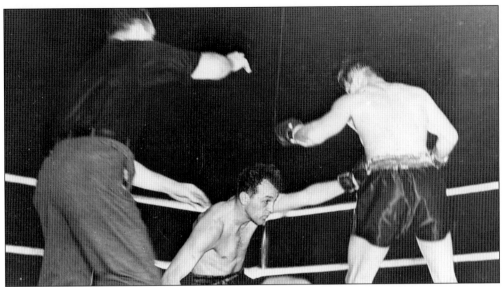

ZALE WINS THE TITLE. In January of 1940 he out pointed the National Boxing Association champion, Al Hostak, in 10 rounds in Chicago. And the following July in Seattle he knocked out Hostak in 13 brutal rounds to win the NBA crown. He KO'd Hostak again, in two rounds, in May of 1941, and on November 28 in New York's Madison Square Garden out-pointed Georgie Abrams in 15 rounds to unify the 160-pound title, which had been in dispute since Mickey Walker relinquished the championship in 1931. Zale was one of the first boxing champions to join up during World War II and he spent the next three years in the U.S. Navy. After the war, Tony and Rocky Graziano had three wars of their own. Zale knocked out Rocky in six rounds in their first meeting, lost on a six-round TKO in Chicago Stadium, and then regained the title by flattening Graziano in three rounds in Jersey City, NJ, in June of 1948. Tony lost the title to Marcel Cerdan in his next fight when he was unable to continue after 12 rounds. He retired, opened a bowling alley in Gary and also became head boxing coach at the CYO in Chicago. Tony Zale, the Man of Steel, died in March of 1997. He was 83.

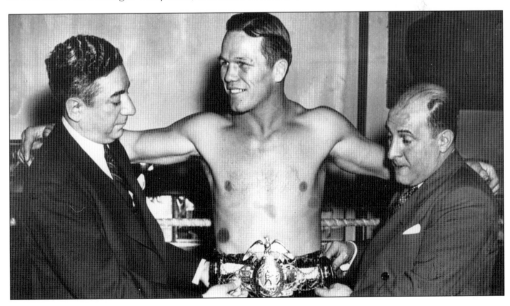

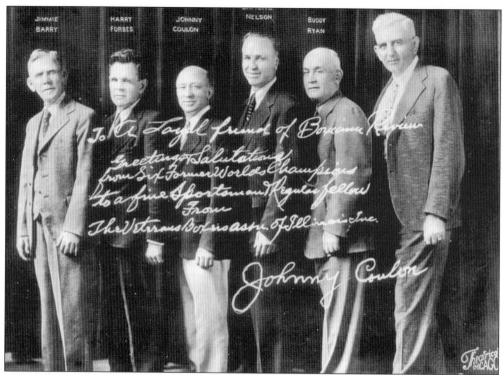

OLD CHAMPS. Pictured above, from left to right, are Jimmie Barry, Harry Forbes, Johnny Coulon, Battling Nelson, Buddy Ryan, and George Gardner.

CHICAGO STADIUM ACTION. Sammy Angott (left) and Davey Day sqaure off at Chicago Stadium. Day won a 12-round decision.

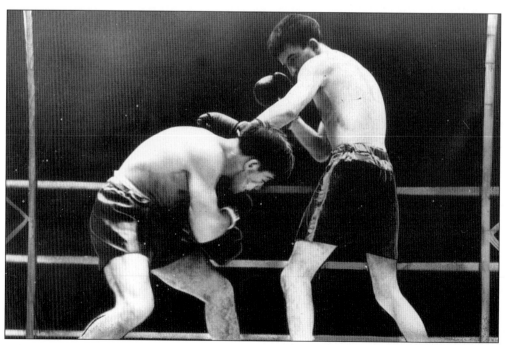

WILLIE JOYCE. From Gary, Indiana, Willie was the classiest lightweight of the 1940s, and he fought every contender and champion who would get in the ring with him. He beat Henry Armstrong in two of their four bouts. He also whipped Lew Jenkins, Leo Rodak, Ike Williams three out of four, Chalky White, and Jackie Wilson. He was managed by George Trafton, Charlie Schuster, and gangster Mickey Cohen. Willie lost to Tippy Larkin in two tries at the Jr. Welterweight Championship. He retired in 1947 after more than one hundred bouts, without ever being knocked out.

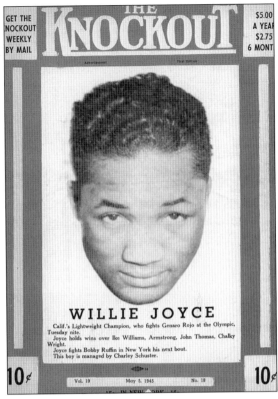

GET THE
NOCKOUT
WEEKLY
BY MAIL

THE KNOCKOUT

$5.00
A YEAR
$2.75
6 MONT

WILLIE JOYCE

Calif.'s Lightweight Champion, who fights Genaro Rojo at the Olympic, Tuesday nite.
Joyce holds wins over Ike Williams, Armstrong, John Thomas, Chalky Wright.
Joyce fights Bobby Ruffin in New York his next bout.
This boy is managed by Charley Schuster.

10¢ 10¢

Vol. 19 May 5, 1945 No. 18

PETE LELLO. Pete was another tough Pole form Gary, Indiana. He was ranked in the lightweight division in 1939 and 1940, and he fought Ray Robinson, Davey Day, Sammy Angott, and Lew Jenkins—who he KO'd.

BOOKER BECKWITH. Another Gary fighter who enjoyed popularity in Chicago, Booker won the 1939 Chicago Golden Gloves and the inter-city and international matches. As a pro, this hard-hitting light-heavyweight beat Lee Oma, Solly Krieger, Red Burman, and Joey Maxim to get a shot at the dangerous Ezzard Charles. Beckwith was KO'd by Charles in nine brutal rounds in Pittsburg, Pennsylvania, after which he was out of action for four years serving in the Army during World War II. He returned to the ring in 1946, had some early success but was stopped by the great Jimmy Bivins, which pretty much finished Beckwith as a title threat.

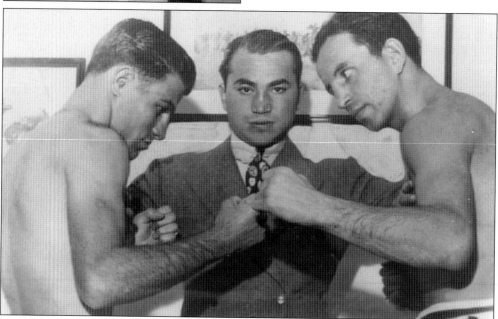

THE WEIGH-IN. Sammy Angott and Davey Day Pose with Barney Ross before their title match on Derby Eve in Louisville, 1940. Angott won a close fight and the NBA title.

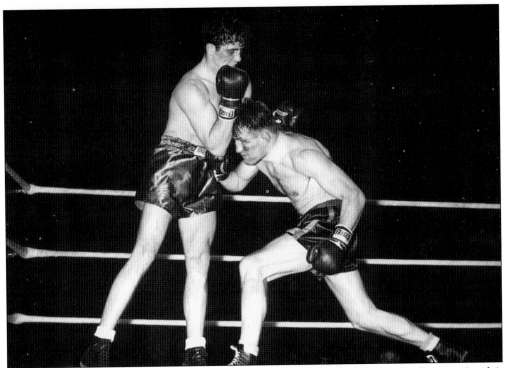

BILLY CONN. Conn (right) stopped rugged Gunner Barlund in the Chicago Stadium on April 4, 1941. he had just given up his light-heavyweight title for a shot a Joe Louis later that summer.

St. Louis, Mo
April 8, 1941

TONY MUSTO—THE BLUE ISLAND TANK. Musto, who was from Chicago's Blue Island neighborhood, fought Joe louis for the heavyweight title on April 8, 1941, in St. Louis. After a hard fight, Tony was stopped in the ninth round.

BARNEY ROSS—WAR HERO. Ross addresses defense plant workers in 1943. Notice the cigarette. Barney died of throat cancer.

A GREAT BUNCH. One of the greatest groups of champions and contenders pose at Johnny Coulon's Gym in 1940. That's Battling Nelson with his shirt off.

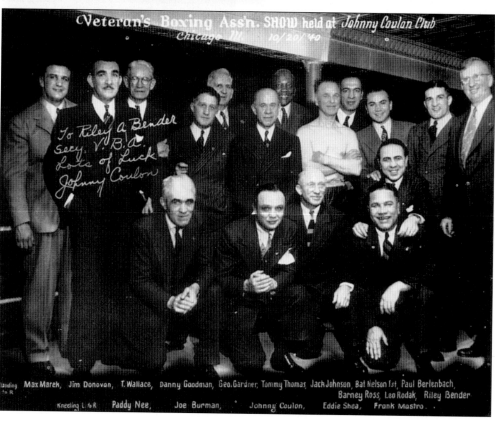

Veteran's Boxing Ass'n. SHOW held at *Johnny Coulon Club*
Chicago, Ill. 10/20/40

To Riley A Bender
Secy V.B.A.
Lots of Luck
Johnny Coulon

Standing Max Marek, Jim Donovan, T.Wallace, Danny Goodman, Geo.Gardner, Tommy Thomas, Jack Johnson, Bat Nelson 1st, Paul Berlenbach, L. to R
Barney Ross, Leo Rodak, Riley Bender.
Kneeling L. to R Paddy Nee, Joe Burman, Johnny Coulon, Eddie Shea, Frank Mastro.

EDDIE LANDER. Eddie was a good Westside Jewish lightweight in the 1930s and 1940s.

BIG BILL PETERSON. Bill, a Southside heavyweight, was a trial horse for many years. He was killed in an auto accident in Cal City in the early 1950s.

HUBBERT HOOD. From the Savoy A.C., Hood was the 1942 Chicago Golden Gloves heavyweight Champion who became a good club fighter in the pros. He tangled with dreaded punchers like Curtis "Hatchet Man" Shepard, Elmer "Violent" Ray, and talented boxers like Joey Maxim.

Best Wishes To My Good Friend Jack Juneau From Hubert Hood 9-4-45

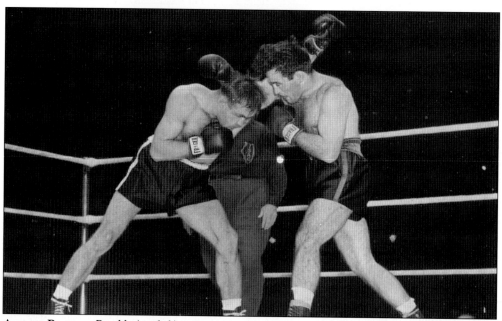

ANTON RAADIK. Raadik (on left) was an Estonian Middleweight contender who fought out of Chicago. Anton reached the peak of his career when he dropped future champ Marcel Cerndan (right) three times at the Chicago Stadium and lost a controversial decision on October 31, 1947.

TOP FIGHTERS OF THE 1940S. Johnny Barbara (left) was a South Bend, Indiana welterweight who became a good club fighter in Chicago. He beat the tough Fritzie Zivic twice in four bouts. Clayton Worlds (center) was a young Southside heavyweight who fought some of the best in the early 1940s—men like Pat Comisky, Turkey Thompson, Al Hart, and Lee Q. Murray. Tony Motisi (right) was a Chicago CYO champ doing well in the pro ranks who beat Fritzie Zivic and Willie Joyce before being knocked out by the great Sugar Ray Robinson in one round in 1942.

BEFORE THE BIG BOUT. Tony Zale (left) and Steve Mamakos pose in the gym before their title bout at the Chicago Stadium on February 121, 1941. Tony won after 14 rounds of savage fighting.

JOHNNY BRATTON—THE NATURAL. Bratton—seen here as a young welterweight *(left)*, on the ticket for his title bout with Carlie Fusari *(center)*, and as a TV star on the cover of *TV Boxing* magazine *(right)*—had more talent than almost any fighter in welterweight history. He also had demons and had several mental breakdowns. But he is best remembered for the three broken jaws he suffered in major fights during his career. Another member of the famed Savoy Boxing Club on the Southside, Johnny was known as "Honey Boy" and was one of the biggest drawing cards in Chicago boxing history.

He started as a pro boxer in 1944 after winning the Chicago Golden Gloves. He gained national prominence by beating the contender Willie Joyce twice in 1946, both bouts in the Chicago Stadium. In the same year he whipped the feared Freddie Dawson and gave Ike Williams a close fight.

He became the rage of Chicago fans, a flashy boxer who could hit hard with either hand. Bratton was attracting huge crowds and with his sharp suits and big Cadillac he started living it up. In 1947, he lost twice to Gene Burton and got out hustled by Sammy Angott. In 1948, Beau Jack gave him his first broken jaw and stopped him in 8 rounds. He started his comeback at the age of 21 and over the next few years won and lost important fights. He suffered his second jaw-breaker when Champ Ike Williams stopped him in 8. Johnny had mental problems that nobody was aware of except for his family, but he kept recovering and fighting the best in boxing.

Finally, after two sensational knockouts scored over contenders Lester Felton and Bobby Dykes, he got his tile shot. He had dumped his longtime manager, gambler Howard Frazier, and his great trainer, Larry Amadee, and then hooked up with Hymie "Mink" Wallman, a

New York manager who had mob connections. Johnny won the Vacant N.B.A. Welterweight Championship by beating Charlie Fusari in 15 furious Rounds at the Chicago Stadium. This fight was televised and "The Brat," as he was also named, was a T.V. favorite from coast to coast.

In his first defense he lost the title to flashy Kid Gavilan in 15 rounds and got his third broken jaw, and also broke a hand. (Johnny was found to have two impacted wisdom teeth; they were removed and he never had any more jaw problems.) He came back and held Kid Gavilan to a draw in a great fight six months later, and over the next few years won and lost some terrific battles—his losses were usually against middleweights.

In all these "wars" he seemed to forget his boxing skills and was taking a lot of punches, which didn't help his fragile mind. And on Nov 13, 1953, in Chicago Stadium, Johnny took one of the worst Beatings ever seen on TV from Kid Gavilan. For 15 brutal heats he cornered Bratton and landed whip lash volleys of blows, and only Johnny's courage allowed him to go the route. He never won another fight. Soon after, the family had him committed to a State Mental Hospital, and he was in and out of hospitals for the rest of life. Johnny would sleep in shelters and wander around Chicago's parks, show up at the racetracks or boxing matches. He was liked by the sport fans of Chicago and they would always put some money in his pockets. In August of 1993 he died of heart failure at the age of 65.

BURRIED AT GRACELAND. Jack Johnson's grave is at Chicago's Graceland Cemetery. He was killed in a car accident on June 10, 1946. His ex-wife, Etta Duryea, is buried in the foreground.

IRV SCHOENWALD—A TOP CHICAGO PROMOTER. Irv Schoenwald's boxing cards at the Marigold Gardens ran from 1933 to 1962, featruring many of the greats of the Golden Age. He also promoted the Chicago Stadium and Rainbow Arena.

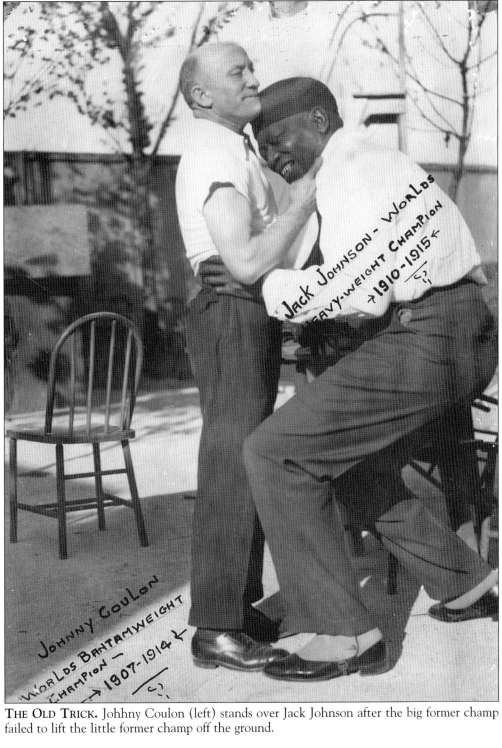

Jack Johnson - Worlds
Heavy-weight Champion
→ 1910 - 1915 ←

Johnny Coulon
Worlds Bantamweight
Champion -
→ 1907 - 1914 ←

THE OLD TRICK. Johnny Coulon (left) stands over Jack Johnson after the big former champ failed to lift the little former champ off the ground.

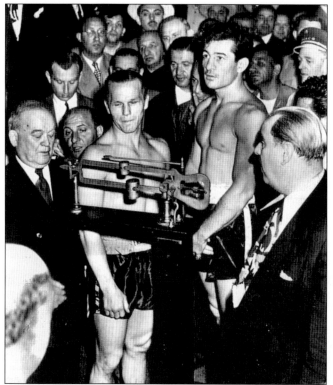

ZALE AND GRAZIANO WEIGH-IN. Zale (left) met Graziano at Chicago Stadium on July 16, 1947, for the second of their three epic battles. He was leading a thrilling fight into the sixth round when Graziano took him out with a devastating barrage. The referee stopped the fight and Zale lost his middleweight title. This fight set the record for the largest indoor gate. (Courtesy of Bob Shepard.)

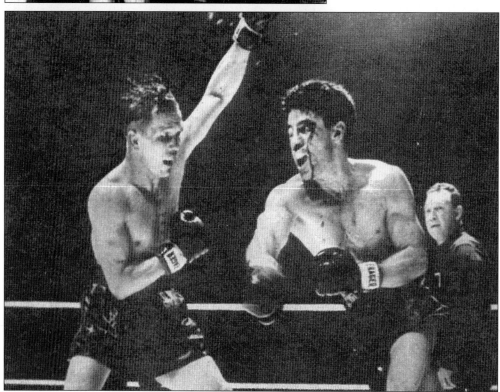

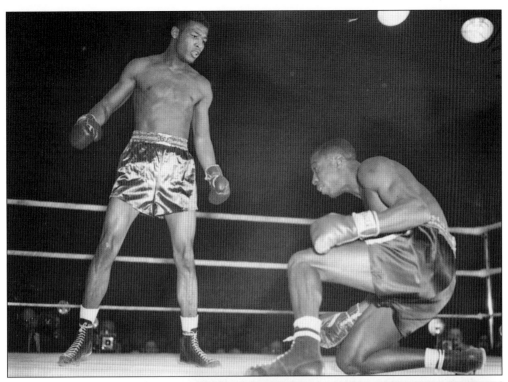

SUGAR RAY ROBINSON AND GEORGE "SUGAR" COSTNER. There was room for only one "Sugar" at Chicago Stadium on February 14, 1945. Robinson (left) knocked out Costner in the first round. He resented Costner's use of the same knickname and flattened him again in one round in 1950.

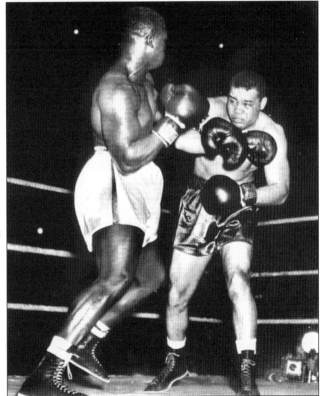

KID RIVIERA AND JOE LOUIS. Riviera, aka Jimmy Williams, was one of the fastest and cleverest big men to box in the 1940s and '50s. He fought many of the top heavyweights of the era, beating most. He was also suspected of being a mob enforcer and was picked up in several mob hits, most notably Alderman Ben Lewis' murder. Williams owned Kid Riviera'a Chicken Shack on the city's Southside.

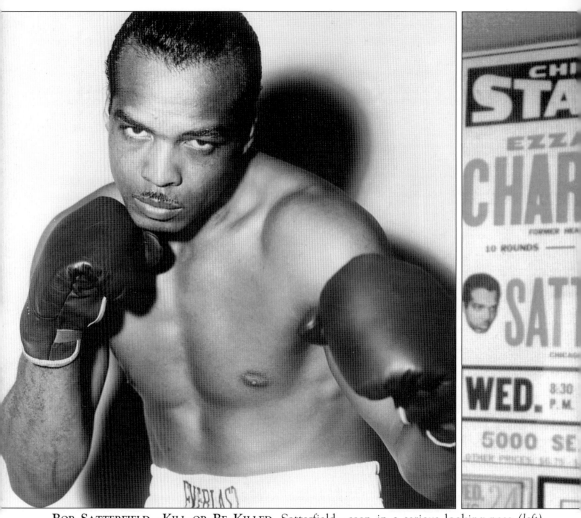

BOB SATTERFIELD—KILL OR BE KILLED. Satterfield—seen in a serious looking pose (*left*), billed as "Chicago's KO Artist" on a promotional poster for a bout with former champ Ezzard Charles (*center*), and landing a right on Joe Maxim's jaw (*right*)—was the greatest action fighter in television history. Bob came out of the Savoy A.C. Amateurs where he had been taught his power punching by Sunny Jim Williams. He could take out anyone with either hand. After winning the Chicago Golden Gloves as a middleweight, Bob turned pro in 1945.

He had a long string of wins by KO and one knockout loss to Mack Parshay. Ike Bernstien, an old Chicago fight manager, took over Bob's contract. In 1946, Holman Williams gave Bob a boxing lesson at the Coliseum, and in a Wrigley Field fight Jake Lamotta stopped him although Bob made his biggest payday that day—$8,500. He was overmatched in both fights. Over the next few years, he KO'd contenders Chuck Hunter, Oakland Billy, Smith Lee Oma, and Sylvester Perkins; and won decisions over Harold Johnson, Nick Barone, Tommy Gomez, and Vern Mitchell. But Satterfield was stopped by Bob Foxworth, Sam Baroudi, Archie Moore, and Henry Hall.

In the 1950s, he scored sensational knockouts on TV over Elkins Brothers, Bob Baker, Julio Mederos, John Holman, and Paul Andrews. But he was stopped by Rex Layne and Clarence

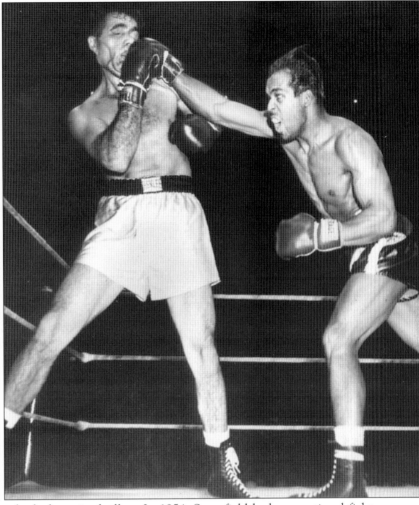

Henry after having them both down in thrillers. In 1954, Satterfield had a sensational fight with ex-champ Ezzard Charles before getting KO'd, but he came right back and knocked out the murderous puncher, Cleveland Williams. Bob was now known and feared as a "spoiler," but his outside-the-ring antics with wine, women, and song were catching up to him. In August of 1955, he got in the best shape of his career and beat the top heavyweight contender, Nino Valdes, in a terrific TV bout, knocking him down in the 10th round.

Bob was back on top as a serious contender, but the handsome playboy enjoyed the ladies and a non-stop series of parties and he slid back into his old bad habits.

The next year he got stopped by John Holman (who he had Ko'd twice) after knocking Holman down a twice. He bounced back in another TV fight, flooring contender Johnny Summerlin and winning the decision in ten. But in his next fight he got stopped by mediocre Harold Carter. Satterfield fought on until the end of 1957, always fighting the best heavyweights, winning and losing but always providing plenty of excitement in the ring. Unfortunately, Robert Wayne Satterfield suffered from cancer and passed on June 1, 1977. He was 53.

HAROLD DADE—CHICAGO'S 5TH BANTAMWEIGHT CHAMP. Dade had one of the shortest championship reigns in boxing history—just two months. He won the 118-pound title from the great Manuel Ortiz on January 5, 1947, in San Francisco, and lost it back to Ortiz in a very close fight on March 11, 1947, in Los Angeles. Though born in Chicago (in 1924), where he won Golden Gloves crowns in 1941 and 1942, Dade turned professional in California and fought only three of his 77 bouts in his home town, out-pointing Charley Riley twice in 1948 and losing a decision to Sandy Saddler the following year. After his loss to Ortiz, he scored a pair of wins over future lightweight champ, Lauro Salas, but he never got another title shot. Although he always gave his best and was a crowd pleaser, his skills began to fail and he retired in 1955. Harold Dade died of cancer on July 17, 1962. He was just 37.

FREDDIE DAWSON—THE DARK DESTROYER. Freddie Dawson was the most feared lightweight fighter of his era. He had every skill to be a champion and almost certainly would have won the title had it not been for his great rival and nemesis, Ike Williams.

As an amateur bantamweight and featherweight in 1941 and 1942, Dawson compiled a 124-2 record and won CYO and Golden Gloves championships, as well as national and international crowns. He turned professional the next year and ran up an impressive win streak before being knocked out in four rounds by the more experienced Williams on September 19, 1944. The match was the first of four with Williams, all held in Philadelphia, Ike's home town. In their second meeting, in January 1946, the boxers fought to a controversial 10-round draw, which most observers thought Dawson had won. Williams beat Dawson again in 10 rounds in January 1948 and then defeated Freddie in 15 very close rounds in a world lightweight title fight on December 5, 1949. Unable to find opponents in the United States, Dawson made four trips to Australia, where he became a fan favorite called the "Dark Destroyer," and KO'd, among others, Aussie champ Vic Patrick. He reportedly had 21 bouts down under and won them all, most by knockouts.

Back in The States, Dawson was forced to fight welterweights. He stumped the experts by knocking out top contender Bernard Docusen and boxing a 10-round draw with the clever George Sugar Costner. In later years he beat Frankie Fernandez, Johnny Gonzalves, and Tommy Bell by knockout, and Luther Rawlings and Bobby Jones on points. Tragically, Freddie Dawson's career was cut short by a detached retina and he retired, at age 30, in 1954. He was later brutally assaulted by a gang of thugs and almost killed, but he recovered partially and moved to California. Freddie Dawson Elston died in Los Angeles on June 7, 1992.

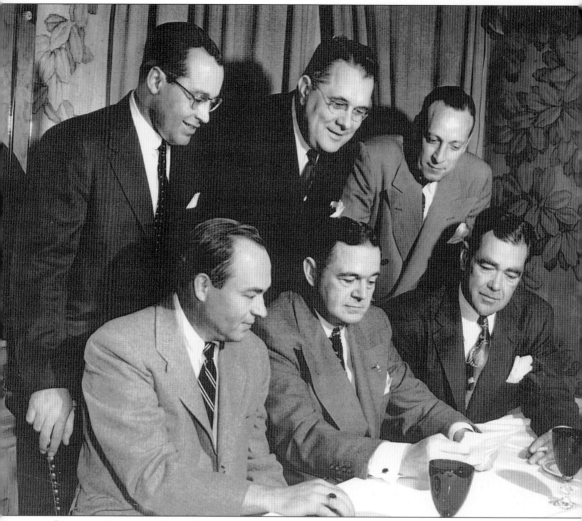

OCTOPUS INC. In 1949, Chicago businessmen James D. Norris and Arthur Wirtz, owners of the Chicago Stadium, Detroit Olympia, and the National Hockey League teams in both cities, formed the International Boxing Club. Along with their skillful lawyer Truman Gibson Jr. they entered into a partnership with the aging heavyweight champion Joe Louis. They also purchased the assets of New York's 20th Century Sporting Club, which promoted television's Friday Night Fights, sponsored by the Gillette Razor Co.

The IBC's first Chicago promotion came after Louis announced his retirement and decreed that the winner of a fight between Ezzard Charles and Jersey Joe Walcott, both of whom had signed IBC contracts, would be the new champion. Charles won a fifteen round decision at Comiskey Park on June 22, 1949, and was recognized in most jurisdictions as the titleholder.

Soon other champions and top contenders in most divisions had signed on with the IBC, which then made an agreement with the Pabst Brewing Co. and Mennen Products to televise the "Wednesday Night Fights" from around the U.S., spotlighting local talent whenever possible. With two major national cards to fill each week, the IBC found it necessary to make deals with some of boxing's shadiest characters. Norris already was friends with Chicago gangster Sam "Golf Bags" Hunt, and he also knew and apparently liked New York mobster Frankie Carbo, the notorious "Mr. Gray" who owned pieces of many boxers' contracts.

106

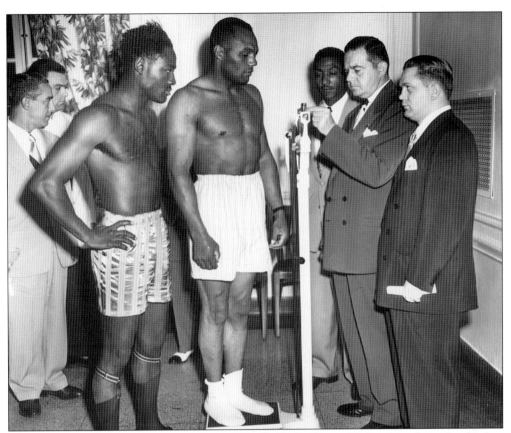

EZZARD CHARLES AND JOE WALCOTT. Charles (left) watches as Walcott weighs-in for the first ever IBC title promotion. The two squared off on June 22, 1949, at Comiskey Park on Chicago's Southside for the vacant heavyweight crown. Charles won a 15-round decision.

How much influence these men had on Norris is uncertain. Gibson, who still practices law in Chicago and is the only survivor of the IBC, says that Carbo never told Norris to make any match, nor did he have any influence on IBC decisions. Still, Gibson concedes, Carbo "hung around" and tried to learn which fights were being considered and then would try to buy into the fighters' contracts. Carbo seems to have had much more influence on the New York managers.

After a decade of "free" television boxing, most of the little fight clubs that had served as incubators for new talent had been put out of business or were barely hanging on. The few promoters around the country who had managed to stay in business were forced to cooperate with the IBC or go out of business.

Finally, the U.S. Department of Justice ruled that the International Boxing Club was a monopoly in violation of the Sherman Anti-trust Act, and in January, 1959, the U.S. Supreme Court upheld the ruling and put "Octopus, Incorporated" out of business for good.

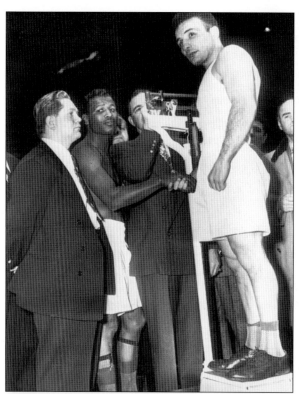

AN EYE FOR AN EYE. Jake LaMotta stands on the scales and shakes hands with Sugar Ray Robinson before their epic February 14, 1951 battle at the Chicago Stadium. He shocked the commissioners and Robinson by saying, "If I get cuts on my eyes don't stop the fight. I'd rather lose an eye than the title."

THE ST. VALENTINE'S DAY MASSACRE. Sugar Ray lands a hard right to the chin of Jake LaMotta, the "Bronx Bull," moments before the referee stopped the slaughter in the 13th round. LaMotta kept his claim of never being knocked out intact. He was even through the first 10 rounds of this great fight, before running out of gas. It was Robinson's fifth win in their six-bout series, and he became a double champion.

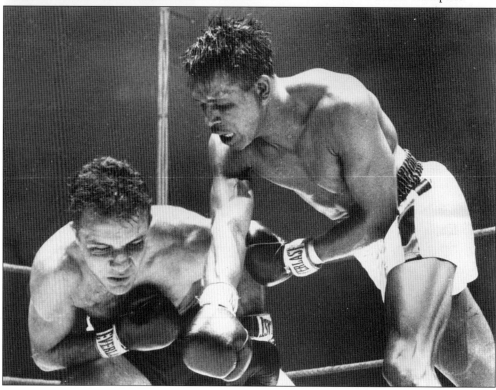

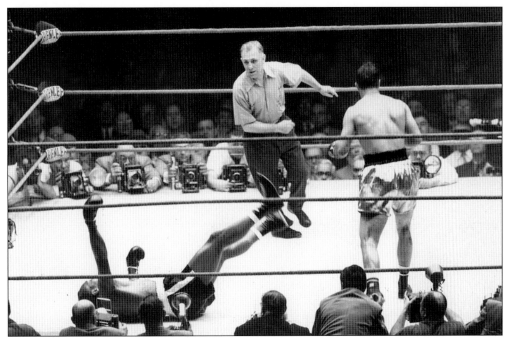

ROCKY MARCIANO AND JOE WALCOTT. On May 15, 1953, Marciano sent Walcott to the canvas for a first-round knockout at Chicago Stadium to retain the title.

SOME OF THE BEST OF THE 1940S AND 1950S. A line up of some of Chicago's best boxers of the 1950s, from left to right, are Richard Hagen, Tom Hickey, Bob Satterfield, Sylvester Perkins, Gene Burton, and Johnny Bratton. Photo taken at Ringside Gym.

JOHN HOLMAN. A good heavyweight with lots of early success, Holman faded from the scene before making a comeback with a knockout win over former champ Ezzard Charles. John lost the rematch but got several lucrative T.V. bouts. His three fights with Satterfield were all thrillers. Holman was managed by Bernie Glickman.

BAT WINS AGAIN. Battling Nelson shows off his wounds after a fight with two muggers who tried to steal his "benny," as he called his overcoat. The 68-year-old Nelson drove off his attackers.

110

LUTHER RAWLINGS—SIX FOOT LIGHTWEIGHT CONTENDER. Rawlings (right) was born Lucius Minor Jr. He started as an amateur at the Savoy A.C., and his great height and fast hands, along with a shifty style, made him a hard man to beat. Managed by Southside gambler Howard Frazier and a stable mate of Johnny Bratton, he also overcame a broken jaw and the tragic death of an opponent, Talmadge Bussey, to become the number one lightweight contender. But Rawlings had to box a lot of welterweight champs and contenders to make a living. He beat the feared Tommy Campbell, Art Aragon, Virgil Akins, and stopped Arthur Persley and Enrique Bolanos. In a non-title bout with lightweight champion Jimmy Carter, he seemed to have no trouble beating the champ but lost a split decision. After that fight, Luther never again got near the peak he attained that night in the Chicago Stadium. He fought on with varying degrees of success and finally retired in 1956 to open a saloon. He is now in his mid-seventies and teaching boxing at St. Leo High School. That's Herbie Schoen (left) and Holman Williams (center). (Photo taken at Eddie Nichols gym at 50th and Indiana.)

BOBBY BOYD. Boyd, a 160 pound Middleweight contender, was born on October 25, 1933 in Chicago.

SPIDER WEBB. Ellsworth (Spider) Webb was an NCAA Champ and 1952 U.S. Olympic Light Middleweight. He was from Tulsa, but fought out of Chicago. Webb beat most of the best boys in his division, including Bobby Boyd, Rory Calhoun, and future champs Joey Giardello, Dick Tiger, and Terry Downes. He lost a close 10 round decision to Gene Fullmer, but in 1959 got a rematch with Fullmer for the N.B.A. Middleweight title. He was out fought and out roughed by Gene, who took a 15 round verdict. Webb retired in 1961 after being stopped by Dick Tiger.

weekly
BOXING
world

Week of
MAY 26, 1958

25 cents

VOL. 2—No. 6

Eddie Borden's Fight Picks of the Week

SPIDER WEBB
Meets Jimmy Beecham at Miami Beach Auditorium
In Ten Rounder on May 30.

See Inside for:
DOWN MEMORY AVENUE

ratings results records predictions

CHUCK DAVEY—CHICAGO'S GOLDEN BOY. Chuck was from Detroit and was on the U.S. Olympic Team in 1948 and had lost only once in more than 150 amateur bouts. He was a Michigan State graduate, built up in Chicago clubs and stadium fights, who became the IBC's "Golden Boy"; they matched him very carefully with trainer Izzy Klien calling the shots. Davey captured TV fans in the 1950s with his good looks and flashy left-hand boxing style, and the ladies really fell for the blond haired college boy. Victories over Chico Vejar, Carmen Basilo, and a washed-up Ike Williams got him a shot at former middleweight champ Rocky Graziano. Davey looked good against the boxer-turned-actor, winning an easy 10-round decision. This earned the Golden Boy a February 11, 1953 title bout with welterweight champ, Kid Gavilan, which attracted a large gate at the Chicago Stadium and a record TV audience. Gavilan gave Davey a beating and stopped in 10 rounds. Davey showed a lot of heart, but was clearly outmatched. He fought on for a few more years before hanging up his gloves to open an insurance company, becoming a millionaire. Davey was tragically paralyzed in a diving accident and later passed away in 2002.

BOBBY BOYD—MOBBED UP MIDDLEWEIGHT CONTENDER.

Boyd turned pro in 1952 and soon developed a big local following. His trainer, Gene Kelly, also taught Benny Meeks and Gene Robnett, both of whom became Golden Glove champs. Boyd could move and had fast hands; he could also punch. Kelly signed up with Bernie Glickman, a Chicago Businessman who had Mob ties and really loved the fight game, to co-manage Boyd. Glickman also loved the limelight when one of his fighters was on TV, and Bobby Boyd soon was appearing on the tube more than any other boxer. He always put on a good show, win or lose. He scored victories over Gene Fullmer and Eduardo Lausse. and KOs over Georgie Johnson and Tony Anthony to get a high ranking in the *Ring Magazine* and NBA ratings. Bobby beat the veterans Holly Mims and Milo Savage, and then ran into a disaster when he suffered a broken jaw and a knockout at the hands of Joey Giardello. Boyd took six months off and put together another streak of wins, including one decision over Rocky Castellani and two over Willie Vaughan, and then got stopped in New York by Rory Calhoun. He started another streak and had some good wins before suffering another KO loss to Spider Webb in a terrific action bout. This finished Boyd as a contender, but he fought on until 1961. His manager, Bernie Glickman, would become involved in the management of other fighters, including champs Virgil Akins and Ernie Terrell, and also would have a narrow escape from death by the Chicago Mob.

WEBB AND MIMS. Spider Webb (right) throws a big right hand at the elusive veteran Holly Mims. Webb won a ten round decision at the Stadium on July 18, 1956.

NENOZ "KING" SOLOMON.
Solomon was a good Northside club fighter in the 1950s. He wasn't Jewish, despite the Star of David on his boxing trunks, but an Assyrian. King was also a legendary horse player. He passed away in September of 2004.

TONY ARVIA AND ROCKY CASSILLO.
Arvia (left) poses with his protoge, Southside welterweight Rocky Cassillo (right), who got TV fans excited when he knocked out Danny Giovanelli, but then was KO'd himself by Vince Martinez.

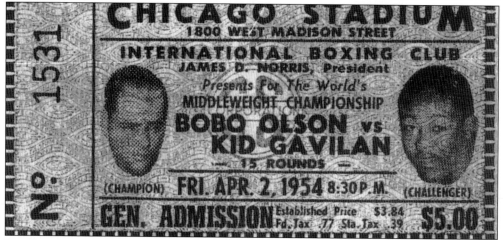

BIG TIME FIGHT TICKETS. Chicago arenas, especially Chicago Stadium, attracted many premier bouts in the 1950s.

FOUR

After the Golden Age

After the IBC died in 1961, boxing in Chicago went down to three shows a year—the golden age was over. But Ernie Terrell, a former fighter, became a promoter in 1977 and promoted eight shows that year. It 1978 it went up to 15 shows, and by 1984 Chicago had up to 30 shows thanks to Ernie promoting fighters like Walter Moore, Jr. , John Collins, Alfonso Ratliff, and Lenny La Paglia. Ernie sparked such a resurgeance of boxing in the city that soon other promoters started to promote shows in Chicago. Today's top promoters in Chicago are Bob Hitz and Dominic Pesoli.

JOHNNY HEARD. Heard, a Middleweight trial horse from 1976 to 1988 fought the best all over the world and had close to 100 bouts.

EDDIE DEMBRY. Dembry was a Chicago 175 lb. Professional from 1964 to 1970. He fought contenders Allen Thomas in 1965, Jimmy Ellis in 1966, and Marion Connor in 1967. He wound up with a 16–7–1 record.

ALFONZO RATLIFF. A native Chicagoan, Ratliff won the Chicago and Intercity Golden Gloves titles in 1980, turning pro that August. He won the WBC World Cruiserweight Title on June 6, 1985, from Carlos De Leon, and then lost the title in September to Bernard Benton. Ratliff was KO'd in two rounds by Mike Tyson on September 6, 1986. He won two close 10-round decisions over Craig Bodzianoski and was KO'd in a battle of Chicago champions by Leroy Murphy in 1989. He retired with a record of 25-6-0 with 20 KOs.

LUKE CAPUANO. Luke Capuano was born in 1953 and weighed 175 lbs. Managed by Blackie Pesoli, he was a pro from 1978 to 1982. He fought Mike Rossman twice in 1981. He retired with a record of 22-4-0 with 21 KOs. (Photo by Tony Fosco.)

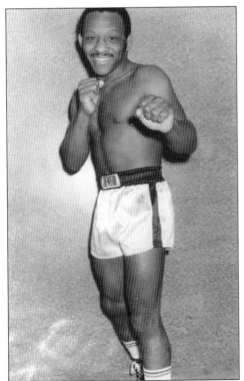

EDDIE PERKINS—COULON'S CHAMP. World Junior Welterweight Champion Eddie Perkins was managed by the great Johnny Coulon. Eddie fought from 1956 to 1975 and won 140-pound title in Milan, Italy, from Dulio Loi on a 15-round decision in September of 1962. He then lost the title to Loi in December by split-decision in Italy. In 98 Professional bouts, Eddie lost 19 decisions and was stopped only once, by Baby Vasquez in Mexico. Perkins fought in South America, Africa, Europe, Australia, and Japan as well as Central America.

FIGHTING IRISHMEN. The O' Shea Brothers, natives of Dublin, Ireland, pictured from left to right, were National Golden Glove Champions: Brian, in 1960 at 135 pounds; Rory in 1962 at 147 pounds; Tom in 1961 at 135 pounds; and Mike (right) was local 1960 novice champion. Brian had a Professional record of 31-4-0, Rory went 29-5-1. Tom went on to coach the Matador Boxing team, which produced five national champions, and also Nate Jones, the 1996 Olympic bronze medalist.

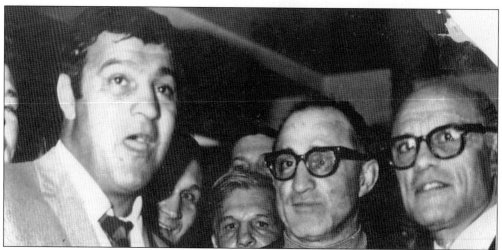

ROCKY MARCIANO. This photo was taken at the Sherman House Hotel in November of 1968 at a fundraiser for the great Ezzard Charles. Pictured from left to right are former heavyweight Champion of the World Rocky Marciano, famous cut man Chuck Vasel Bodak, and the CYO Boxing Director Mike Triolo. Marciano would parish in an airplane accident the following August.

CRAIG BODZIANOWSKI. Bodzianowski won the 1981 Chicago Golden Gloves. He turned pro on October 16, 1892 and had his last bout on December 17, 1993. In 1984 he lost his right foot in a motorcycle accident. He then fought with a prosthesis. He fought two exciting 10 rounders with Alfonzo Ratliff in 1987 and 1988. He lost a close 12 round decision for the WBA Cruiserweight title to Robert Daniels on July 19, 1990. His record was 31-4-1 with 23 KOs.

CRAIG BODZIANOWSKI. Bodzianowski with Pope John Paul II in Rome, Italy.

HARD LUCK HEAVYWEIGHT. Jim Finn lost an exciting close decision to Graig Bodzianowski for the Chicago Golden Gloves title in 1981. He turned pro the following year and won all 15 of his pro fights until May of 1986, when it was discovered he had a detatched retina and was forced to retire early.

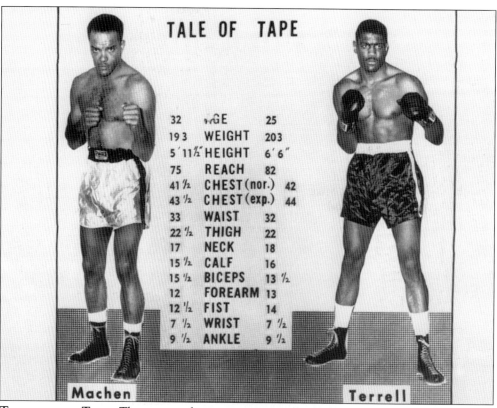

TALE OF TAPE

Machen		Terrell
32	AGE	25
193	WEIGHT	203
5′11½″	HEIGHT	6′6″
75	REACH	82
41½	CHEST (nor.)	42
43½	CHEST (exp.)	44
33	WAIST	32
22½	THIGH	22
17	NECK	18
15½	CALF	16
15½	BICEPS	13½
12	FOREARM	13
12½	FIST	14
7½	WRIST	7½
9½	ANKLE	9½

Machen **Terrell**

TALE OF THE TAPE. These were the measurements for the March 5, 1965 vacant WBA Heavyweight title bout at Chicago's Ampatheatre between Eddie Machen and Ernie Terrell. Terrell won a 15 round decision.

ERNIE TERRELL. He won the National and Intercity 175-pound Golden Gloves in 1957 at the age of 17 and turned professional in April of 1957 while still in high school. Terell beat Cleveland Williams, Zora Foley, and Bob Foster, but lost a 15-round decision to Muhammad Ali in 1967. Ernie retired to go into the Music business in 1973 with a professional record 46-9-0 with 21 KOs. He became a very successful boxing promoter in 1977. (Photo courtesy of Gordon Volkman.)

JAMES QUICK TILLIS. A heavyweight contender. managed by Jim Kalentis and trained by Rory O'Shea, Tillis came to Chicago in 1978 and had his first professional bout at the Aragon Ballroom. He fought Mike Weaver for the WBA Heavyweight Title, losing a 15-round decision at the Rosemont Horizon in 1981. World champions he fought were Greg Page, Tim Witherspoon, Pinklon Thomas, Gerrie Coetzee, and Mike Tyson. (Photo by Steve Corbo.)

OPENNING OF A NEW ARENA. On July 29, 1995, accross the street from where Chicago Stadium once stood, the Mexican National Anthem played before the first Boxing card held at the new United Center. It was between the 140-pound world champion, Julio Cesar Chavez (center of photo), and challenger Craig Houk. (Photo courtesy of James Kitchen.)

To my friends at
The Ill. Boxing Comm.
Thanks for your support
and assistant.
Best Wishes
Choir Boy
Landini

MIKE "THE CHOIR BOY" LANDINI. Fighting professionally from 1981 to 1989, in March of 1985 Landini won the 160-pound. Midwest Title from Carlos Tite on a split-decision in Hammond, Indiana. He was KO'd by Johhny Collins at the Illinois Pavilion for the State Middleweight Title in October of 1985. He retired in 1989 with professional record of 30-3-0 with 15 KOs.

LIRA AND ESPANA. Ernesto Espana (right) defended his world lightweight title in Chicago with a 10th-round TKO over John Lira (left) on August 4, 1979. The fight was called due to cuts suffered by Lira. (Photo by Steve Corbo.)

124

JOHN COLLINS. This 6-foot-1 middleweight, trained by Tony Arvia, turned professional in 1980. On August 3, 1985, in Scranton, Pennsylvania. he won the USBA Title by a second-round knockout over Mark Holmes, the brother of heavyweight champion Larry Holmes. In March of 1986, in Las Vegas, Collins lost the title to Robbie Sims, the brother of Marvin Hagler. His professional record was 34-2-1 with 30 KOs. (Photo courtesy of Frank Glienna.)

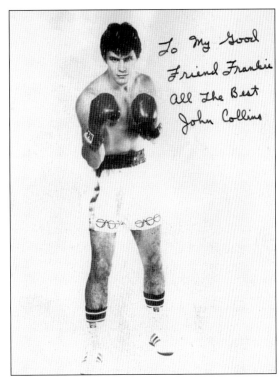

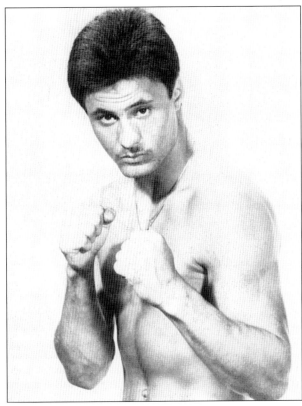

LENNY LA PAGLIA. Trained by Primo and Pat LaCassa, La Paglia turned pro in 1980. In Chicago's big bout of 1983, Lenny lost a close 10-round decision to John Collins at the Illinois Pavilion for the state 160-pound title. In 1986, he won the Illinois State 160-pound Title with a KO in 10 over Mike Moore at the Di Vince Manor. He won the IBO World 175-pound Title in 1993 over Darryl Fromm at the Millford Ballroom. His last fight was for the WBU Cruiserweight Title when he was KO'D by Thomas Hearns in Detroit, Michigan. La Paglia's professional record was 36-9-0 with 33 KO's.

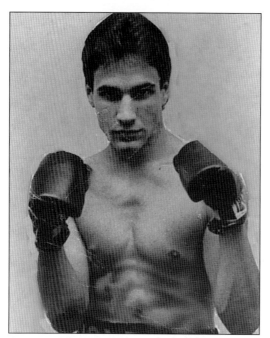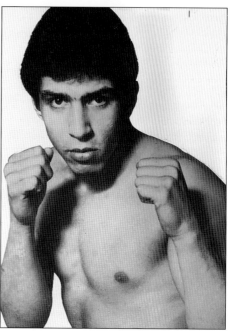

CHICAGO CONTENDERS. Two of the city's top boxers in the 1980s were Jeff Lanas *(left) and* Louis "KO" Mateo *(right)*. Lanas won the 1982 Chicago Golden Gloves and became a top pro from 1983 to 1991, losing a disputed split-decision to future middleweight champ, Robereto Duran, in October of 1988. He retired with a record of 19-4-0. Mateo was trained by Pat and Primo LaCassa and beat Kid Clayton, for the state title, in 1990. He retired with a 22-6-0 record and 11 KOs.

REYNALDO SNIPES. Managed and advised by Rev. Jim Williams, Snipes won the 1978 Chicago Golden Gloves Heavyweight Title and turned pro that November. He fought Larry Holmes for the WBC Title on November 6, 1981, and was stopped in the 12th round after knocking down Holmes in the eighth. He also fought champions Greg Page, Gerrie Coetzee, Trevor Berbick and Tim Witherspoon. Snipes ended his career in 1993 with a record of 42-10-0 with KOs.

OLIVER McCALL. McCall was born April 4, 1965 in Chicago. At 220 lbs., he turned pro on November 2, 1985. On March 9, 1994 he won the WBC Heavyweight Title from Lennox Lewis with a KO in two rounds in London, England. On April 8, 1995 he defended his title successfully with a 12 round decision over former champion Larry Holmes, but on September 2, 1995 he lost the title to Frank Bruno in a 12 round decision in London. On February 2, 1997 McCall lost by a fifth round TKO in his rematch with Lewis in a bout where he broke down emotionally. His record is 40-7-0 with 30 KOs. (Photo by Tony Fosco.)

JESUS "EL MATADOR" CHAVEZ. Chavez, aka Gabriel Sandoval, came to Chicago from Mexico at the age of six. He turned professional in 1994 and won the WBC World Super Featherweight Title in 2003, beating Samuk Sim of Thialand. Chavez lost the title the following February to Erik Morales in Las Vegas. He had a professional record of 40-3-0 with 28 KOs.

MARK RANDAZZO. Randazzo was born August 8, 1966, and turned pro on September 3, 1988, at 190 lbs. On June 9, 1994 he won the WBC Americas Cruiserweight Title with a third round TKO of Lonnie Horn at the Rosemont Horizon. On September 30, 1995, he lost a 12 round decision to Ralf Rocchigiani for the WBO Cruiserweight Title in Hanover, Germany. He retired in 1997 with a record of 29-1-1 with 16 KOs. (Photo by James Kitchen.)

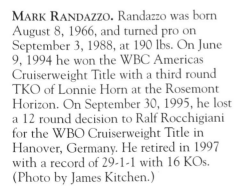

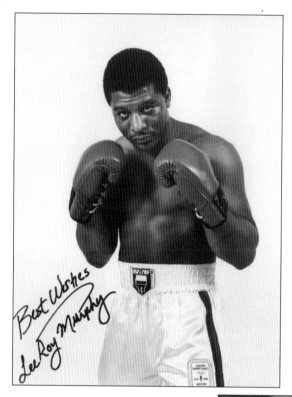

LEROY MURPHY. Trained and advised by Jim Strickland, local boxer Leroy Murphy became the 178-pound National Golden Glove Champion in 1979 and the 1980 Olympic Trials Champion. He turned professional on November 13, 1980, with a second-round knockout over Roger Moore. he then won the IBF World Title on a 14th-round TKO over Marvin Camel in 1984. Murphy defended his title against Chicago's Young Joe Louis with a 12-round TKO, in December 1984, at Chicago's Bismark Hotel. In 1985, he KO'D Cisandra Mutti in Monte Carlo after being floored twice. In 1986, he KO'D Dorcey Gaymon in San Remo, Italy. In his next bout he lost the title to Ricky Parkey by a 10-round TKO in Marsala, Italy. In 1989, Murphy KO'D former WBC Champion Alfonzo Ratliff in four rounds. He had a professional record 30-4-0 with 22 KOs.

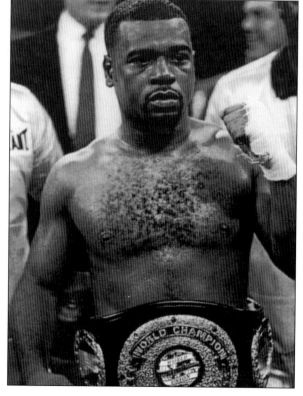

MONTEL GRIFFIN. Managed by John Caluwaert, Griffith began his professional career in 1993. In 1996, he beat James Toney for the WBU 175-pound crown, and then in 1997 he upset Roy Jones Jr. for the WBC Title. Griffin lost the title to Jones later that year by a KO in the first round. His professional record was 44-4-0 with 29 KO's. Montel won a Bronze Medal at the 1992 Olympics.